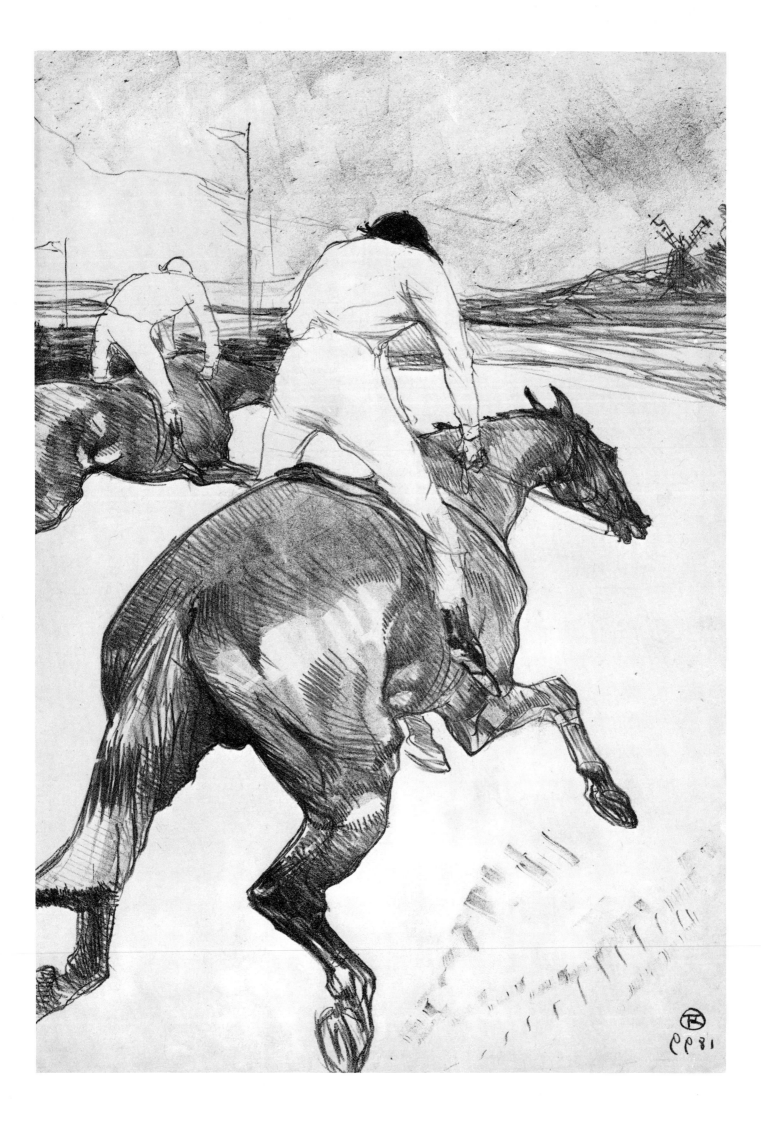

Henri de Toulouse-Lautrec

GREAT LITHOGRAPHS BY TOULOUSE-LAUTREC

89 Plates, Including 8 in Full Color

Theodore B. Donson **and** Marvel M. Griepp

DOVER PUBLICATIONS, INC., NEW YORK

Preface

It has been said that on the whole the lithographs of Toulouse-Lautrec are a more innovative, exceptional body of work than his paintings. Few artists have so successfully exploited a printmaking medium. Lautrec was captivated by lithography and employed it for a wide range of expressive purposes, from the delicate drawing of a little mouse to the broad patterning of a bawdy cabaret singer. The works reveal all the riches of this incomparable artist: his acute powers of observation and his humanity, his flamboyant approach to color and his marvelous draftsmanship, his manipulation of a lithographic stone to convey both subtle and dynamic imagery.

All but twelve of the lithographs illustrated in this book were exhibited at the Theodore B. Donson Gallery, 38 East 57 Street, New York, N.Y. 10022, during the spring of 1980.

FRONTISPIECE: Plate 80. The Jockey — Racehorses. 1899.

Copyright © 1982 by Theodore B. Donson and Marvel M. Griepp.
All rights reserved under Pan American and International Copyright Conventions.

Published in Canada by General Publishing Company, Ltd., 30 Lesmill Road, Don Mills, Toronto, Ontario.
Published in the United Kingdom by Constable and Company, Ltd., 10 Orange Street, London WC2H 7EG.

Great Lithographs by Toulouse-Lautrec is a new work, first published by Dover Publications, Inc., in 1982.

Book design by Paula Goldstein

Manufactured in the United States of America
Dover Publications, Inc., 180 Varick Street, New York, N.Y. 10014

Library of Congress Cataloging in Publication Data

Toulouse-Lautrec, Henri de, 1864–1901.
 Great lithographs by Toulouse-Lautrec.

 Bibliography: p.
 1. Toulouse-Lautrec, Henri de, 1864–1901—
Catalogs. I. Donson, Theodore B. II. Griepp,
Marvel M. III. Title.
NE2349.5.T68A4 1982 769.924 82-4521
ISBN 0-486-24359-1 AACR2

Biographical Notes

1864 Henri-Marie-Raymond de Toulouse-Lautrec-Monfa was born November 24 at Albi, in the château of his parents, Comte Alphonse de Toulouse-Lautrec and the Comtesse Adèle, née Tapié de Céleyran, cousin of the Count. As a boy he lived in the Château du Bosc at Albi, at Céleyran and, some time later, at school in Paris. He drew incessantly from an early age.

1878 He slipped and broke a leg at the Château du Bosc and remained bedridden a long time. During a visit to Barèges the next year he broke the other leg. As a result, his legs never developed; he grew a normal torso, which was supported by weak and stunted legs.

1881 He obtained a *baccalauréat* at Toulouse and then went to Paris to study art under René Princeteau, a deaf-mute painter of animals and a friend of his father.

1882 He enrolled in the studio of the academic painter Léon Bonnat and later entered that of Cormon, where he worked alongside Emile Bernard and (several years later) Vincent van Gogh.

1885 He rented a studio at 7 rue Tourlaque, where he remained for thirteen years. He actually did most of his work in Montmartre dance halls, cabarets, brasseries and circuses, especially Le Moulin-Rouge, Le Moulin de la Galette, Le Divan Japonais, Le Mirliton, Le Jardin de Paris and Les Ambassadeurs.

1889–1890 He first showed at the Salon des Indépendants and exhibited with Les XX in Brussels.

1891 He executed his first poster, *Moulin-Rouge (La Goulue)*, which brought him immediate celebrity.

1892 He executed his first lithographs in black and white and in colors. He began residences in various brothels.

1893 Goupil Galleries, Boulevard Montparnasse, staged a first exhibition of his work, together with that of Charles Maurin.

1895 He continued painting and executing lithographs of theatrical personalities and cabaret entertainers, daily visiting the workshops of his lithography printers. He began making trips to London, where he met Oscar Wilde, Aubrey Beardsley, Arthur Symons and others.

1896 Goupil Galleries mounted a second exhibition of Lautrec's work, evidencing a continued intense concentration on prints, posters and book illustrations.

1898 Lautrec's health began to deteriorate drastically from the effects of alcohol.

1899–1900 Lautrec was confined to a sanatorium at Neuilly, adjacent to Paris, following an attack of alcoholism and a physical breakdown. He remained there convalescing for three months and made 39 circus drawings from memory. Upon recovery he returned to his Paris studio and traveled around France.

1901 The effects of alcohol again debilitated Lautrec. He died in bed, with his mother in attendance, at Malormé, September 9.

Critics' Comments

Ah, the lithographs! They are Lautrec's most significant and enjoyable work, superior to his paintings, whatever one may say. In them he was able to allow his imagination free rein. Truly, it was in printmaking that Lautrec gave of his best.—GUSTAVE COQUIOT

Lautrec is not an executant, a craftsman interested in the finished engraving. To him, lithography is a painter's art . . . and his work as a painter is in general subordinated to his work as a lithographer. If we reread Joyant's catalogue, . . . we constantly find paintings referred to as sketches, projects or studies for a lithograph or a poster.—JEAN ADHÉMAR

There was a little man, a very ugly little man, who beneath the aspect of Caliban concealed the fantasy of Ariel. Though devoured by bitterness, he delighted in everything about him; though born in the provinces, he knew Paris better than the Parisians; though his style and manner were those of an artistocrat, he drew his inspiration from the barest walks of life; in the brief span accorded him . . . he left more numerous, more precise, more moving records of the age in which he lived than any of his contemporaries. . . .

Working in the silence of the print shops, face to face with a block of stone . . . , Lautrec, with nothing more to go by than a tiny sketch, was enabled by his astonishing memory to recover intact his original sensation, to translate every gesture and every form. . . . It is perhaps in the drawings on stone . . . that Lautrec's gifts of observation and transfiguration are most eminently displayed. We shall hardly belittle the painter, if we say that we prefer the lucid engraver, . . . equipped only with a crayon and a little diluted ink, working over a stone whose skin is as sensitive, as capricious as the skin of a woman. . . .

His name suddenly imposed itself on the public through his large posters. . . . Though they still reveal the influence of the Japanese, their very flamboyance is tempered by the surest taste. . . . But in his later work these brilliant orchestrations, this open-air music, exploding on every billboard, is followed by a chamber music, more intimate and still more exquisite: the small print. . . .

Reduced to their quintessence, even those works which deal with the crudest and most cruel aspects of everyday life border on poetry. No one, except for Whistler, had ever derived such purity from a lithographic stone. . . . More and more, his line seemed to graze the stone, to dream, to pause and then take flight, to pause again on the parting of two lips, on a nostril, the lobe of an ear, the corner of an eyelid. Never has lighter hand assisted an eye more discerning, more curious, more eager. Never has an artist eliminated the nonessential with greater insight and decision.—CLAUDE ROGER-MARX

Selected Bibliography

Adhémar, Jean. *Elles*. Monte Carlo: André Sauret, 1962.

Adhémar, Jean. *Toulouse-Lautrec: His Complete Lithographs and Drypoints*. New York: Harry N. Abrams, 1965. Paris (French): Arts et Métiers Graphiques, 1965.

Adriani, Götz, and Wittrock, Wolfgang. *Toulouse-Lautrec: Das gesamte graphische Werk*. Cologne: DuMont Buchverlag, 1976.

Arts Council of Great Britain. *Toulouse-Lautrec, 1864–1901, His Lithographic Work from the Collection of Ludwig Charell*. London: 1951.

Bodelsen, Merete. *Toulouse-Lautrec's Posters*. Copenhagen: The Museum of Decorative Arts, 1964.

Charpentier, Galerie. *Ensemble exceptionnel d'estampes originales, livres illustrés . . . de Henri de Toulouse-Lautrec: collection M. L.* (Maurice Loncle sale catalogue). Paris: 1959.

Coquiot, Gustave. *Henri de Toulouse-Lautrec*. Paris: 1913.

Delteil, Loÿs, ed. *Le Peintre-Graveur Illustré: Toulouse-Lautrec*. Vols. 10 and 11. Paris: 1920. Reprint, New York: Da Capo Press, 1969.

Donson Ltd., Theodore B. *Henri de Toulouse-Lautrec: Performers of the Stage and the Boudoir* (exhibition catalogue). New York: 1980.

Fermigier, André. *Toulouse-lautrec*. New York: Frederick A. Praeger, 1969.

Garvey, Eleanor M., and Hofer, Philip. *The Artist and the Book, 1860–1960*. Boston: Museum of Fine Arts, 1961. 2d ed., 1972.

Goldschmidt, Lucien, and Schimmel, Herbert. *Unpublished Correspondence of Henri de Toulouse-Lautrec*. New York: Phaidon Publishers, Inc., 1969.

Huisman, P., and Dortu, M. G. *Lautrec par Lautrec*. Lausanne and New York (English), 1964.

Joyant, Maurice. *Henri de Toulouse-Lautrec, 1864–1901*. 2 vols. Paris: Floury, 1926–1927.

Julien, Edouard. *Les Affiches de Toulouse-Lautrec*. Monte Carlo: André Sauret, 1950.

Kornfeld, Eberhard W. *Graphik von Edvard Munch–Henri de Toulouse-Lautrec* (auction sale catalogue for the Clarence and Jane Franklin collection). Berne: Kornfeld und Klipstein, 1973.

Mack, Gerstle. *Toulouse-Lautrec*. New York: Alfred A. Knopf, 1938.

Sotheby & Co. *Catalogue of a Collection of Fine Lithographs and Drawings by Henri de Toulouse-Lautrec* (auction sale catalogue for the Ludwig Charell collection). London: October 6, 1966.

Sotheby Parke Bernet & Co. *Henri de Toulouse-Lautrec Lithographs from the Collection of Ludwig & Erik Charell*. London: April 27, 1978.

Stuckey, Charles F. *Toulouse-Lautrec: Paintings*. Chicago: The Art Institute, 1979.

Wick, Peter A. *Toulouse-Lautrec Book Covers & Brochures*. Cambridge: Department of Printing and Graphic Arts, Harvard College Library, 1972.

Wick, Peter A., intro. *Yvette Guilbert . . .* (facsimile edition). New York: 1968.

Concordance

The "D" numbers are those of Delteil, the "W" those of Wittrock and the "A" those of Adhémar (see the Selected Bibliography and the preliminary statement in the List of Plates). Only lithographs reproduced in the present volume are included.

D.	W.	A.	D	W.	A.	D.	W.	A.	D.	W.	A.
						154	270	178	261	279	302
						158	274	172	272	310	290
						165	66	104	279	356	365
						169	204	218	290	315	324
11	3	2	86	84	93	178	191	212	305	334	341
12	4	3	90	88	97	179	177	200	308	337	344
14	38	40	91	89	98	180	178	201	339	1	1
16	71	72	98	104	108	181	179	202	341	9	11
17	10	10	100	103	112	182	180	203	343	5	6
18	28	19	102	118	131	183	181	204	345	11	12
20	30	21	103	119	134	184	182	205	348	14	15
23	33	22	104	115	128	186	184	207	351	56	68
28	17	28	105	116	129	188	186	209	352	109	9
33	22	35	106	114	127	192	171	193	353	59	69
35	24	36	108	123	138	206	207	230	354	136	116
39	8	8	112	128	117	209	212	257	355	108	115
40	42	43	116	65	105	210	210	252	356	138	149
43	45	46	125	125	139	216	237	228	358	141	150
45	47	48	127	107	111	219	216	322	361	165	198
57	60	62	129	147	158	220	240	272	362	143	189
61	69	65	133	151	154	230	298	273	366	145	188
64	76	42	141	159	152	252	257	308	367	360	323
68	72	73	142	160	162	254	259	310			
71	99	77	143	162	160	257	261	313			
84	82	91	150	266	166	259	263	315			

List of Plates

The titles, dates and numbers in the entries follow those in Wolfgang Wittrock's catalogue raisonné of Toulouse-Lautrec's prints that appears in the work by Adriani listed in the Selected Bibliography. The Concordance that precedes this List of Plates provides transposition from the numbers ("D") in the source most frequently cited, the Delteil catalogue raisonné (see Bibliography), to the Wittrock numbers used here ("W"), as well as to those ("A") in the Adhémar listing (second item in Bibliography). These abbreviations are also used in the List of Plates. The Roman numbers or other lettering pertain to states. Dimensions are given in both millimeters and inches, height preceding width. The eight color plates, numbered A through H, are in a section of their own, following black-and-white plate 16, but in this List of Plates they are described in their proper chronological sequence. Color plates A and B are thus described after black-and-white plate 7; C is described after 23; D after 44; E after 54; F after 62; G after 64; and H after 80. The captions on the plate pages are English translations of the French titles used in this List. Plate 80 appears as the frontispiece.

1. MOULIN-ROUGE (LA GOULUE). Lithograph printed in colors on two sheets of wove paper, with lettering for use as a poster, 1891 (W. 1 ii/iii; D. 339 i/ii; A. 1 ii/iii). 1680 × 1175 mm.; 66⅛ × 46¼".

The elevation of the poster to an art form was largely attributable to the efforts of one man, Jules Chéret, who imported from England the techniques of mechanical printing and applied them to the production of colorful and entertaining designs. Almost mocking the forbidding and sober mood of Salon paintings, Chéret's legions of *Chérettes,* the pink, plump and healthy young ladies who populated his posters, confronted and delighted Parisians on every street corner.

By 1880, the poster had become the people's art, reflecting the pace of modern life and diverting the urban working population. For Toulouse-Lautrec, who was strongly motivated not only by Baudelaire's exhortations to the modern painter to base his designs upon direct experience of life, but also by Japanese art, which made no distinction between pure and applied art, the poster provided an obvious outlet.

Therefore, when Charles Zidler, manager of the Moulin-Rouge, approached Toulouse-Lautrec to execute a poster for the fall 1891 opening, he happily accepted the commission. Lautrec's design brought him immediate recognition for its brilliant evocation of Montmartre nightlife, its flattened perspective and its distinctive decorative effects, such as the human background frieze and the sinister silhouette of Valentin rising from the picture plane, betraying a debt to Japanese woodblock prints.

La Goulue was born in 1870 as Louise Weber, destined for the laundering trade. She began her dancing career at 17 at the Moulin de la Galette, and rapidly earned her nickname, "The Glutton," by a formidable appetite for food and drink and, according to one author, her ability to swallow in a single mouthful any and every man who came her way. Engagements at the Elysée-Montmartre and the Jardin de Paris culminated in 1890 in her installation at the Moulin-Rouge, where she led her fellow artists Valentin le Désossé (The Boneless Wonder), Mlle Grille d'Egout (Miss Sewer Grating) and Guibollard (Leggy) in the *quadrille naturaliste* for almost five years.

A contemporary newspaper account (*Gil Blas,* May 10,

1891) described the memorable technique which secured La Goulue's triumph over all rivals: "The moment she began to dance her cheeks glowed, unruly locks broke loose, her arms rose, her legs swung up, beating the air, threatening the spectators' hats and drawing their avid eyes towards the elusive opening of her embroidered drawers. . . . As the figures of the *quadrille* succeed one another, she alternates the tantalizing arching of her belly with a lascivious wriggle of the hips. Slowly concluding a *bouillonnement,* she allows the spread of her legs to be glimpsed through the froth of pleats and reveals clearly, just above the garter, a tiny patch of real, bare skin. And from that scrap of rosy skin, as from molten steel, a scorching ray darts out to strike the breathless spectators."

Silhouetted against the figure of La Goulue is Valentin le Désossé (Jacques Renaudin, 1843–1907), a remarkably loose-jointed dancer who partnered her from her first appearances at the Moulin de la Galette to her last at the Moulin-Rouge (see No. 29). Their distinctive style and appearance made them a favorite of the Montmartre crowds.

2. AU MOULIN-ROUGE — LA GOULUE ET LA MÔME FROMAGE. Lithograph printed in colors on wove paper, 1892 (W. 3 iii/iii; D. 11; A. 2). Signed in pencil by the artist and numbered typographically in red, from the edition of 100 impressions. Stamped with the oval stamp of the printer, Edw. Ancourt & C^{ie}. 460 × 345 mm.; 18⅛ × 13⅝".

Gratified by the success of his poster, Toulouse-Lautrec again presented La Goulue, this time in a smaller format. Here she is seen as the Queen of Montmartre, strolling haughtily on the arm of her constant companion, La Môme Fromage (Kid Cheese). Once the youngest in a couturier's workshop, La Môme Fromage was adopted by La Goulue during an engagement at the Elysée-Montmartre and became one of the regular troupe at the Moulin-Rouge. Yvette Guilbert recalled in her memoirs that La Goulue lived for a time with a "strange little dancer who looked like a kitchen maid, . . . a dachshund turned into a woman, short of leg, long of body, plumpish, with a servant-type face — a Venus of the barracks. I do not know how she acquired her name of Môme Fromage." Goulue denied that she and La Môme Fromage were anything more than close friends. La Môme Fromage insisted they were lovers.

3. L'ANGLAIS AU MOULIN-ROUGE. Lithograph printed in colors on Van Gelder paper with a Crowned Lily watermark, 1892 (W. 4 ii/ii; D. 12; A. 3). Signed by the artist and numbered in pencil, from the edition of 100 impressions. 500 × 372 mm.; 19⅝ × 14⅝".

The Englishman is W. T. Warrener, an impresario for small English theaters who frequented the dance halls and café-concerts of Montmartre to recruit Parisian performers. The influence of Japanese prints is manifest.

4. AMBASSADEURS: ARISTIDE BRUANT. Lithograph printed in colors on two sheets of wove paper with lettering for use as a poster, 1892 (W. 5; D. 343; A. 6). 1338 × 917 mm.; 52⅝ × 36⅛".

Aristide Bruant, a "lord among pimps, with a face like a Roman emperor, in his ribbed velvet suit, with his high boots and red scarf and his rough, arrogant voice" (Jules Lemaître), spewed caustic invective and sang his own tragic, cynical or ribald verses before enthusiastic cabaret

crowds. His songs display great literary intelligence, and Bruant himself was a hypnotic entertainer and a shrewd entrepreneur. In 1885, after years of appearing at various Paris cabarets, he took control of the premises vacated by the Chat Noir, renaming the place Le Mirliton. It was there that Bruant captivated Lautrec. Lautrec, in turn, captured the personality and costume of his friend and immortalized him on four posters executed during 1892 and 1893. The story is told that Bruant refused to appear at Les Ambassadeurs until the proprietor, Ducarre, agreed to circulate the brash poster that Bruant had commissioned from Lautrec to publicize his appearance, and to pay the artist his full fee.

5. MISS LOÏE FULLER. Lithograph printed in two colors on wove paper and embellished by the artist with gold powder, 1892 (W. 8 iii/iii; D. 39; A. 8). From the edition of 50 unnumbered impressions, each individually embellished with gold or silver powder. 370 × 260 mm.; 14½ × 10¼″.

Loïe Fuller was a Chicago-born American who began her stage career as a singer at age five and went on to give temperance lectures at age 13. After several unsuccessful appearances with a barnstorming Shakespearean repertory company, she turned to dancing and evolved a highly individual style involving veils of flowing drapery which she whirled through colored lights produced by electric reflectors. These manipulations brought her great success at the Folies-Bergère. Jean Lorrain wrote in the *Echo de Paris* of "this beautiful girl who, in a swirl of vaporous skirts, writhes and swoons under triumphal lights."

6. DIVAN JAPONAIS. Lithograph printed in colors on wove paper for use as a poster, 1893 (W. 9; D. 341; A. 11). 810 × 625 mm.; 31⅞ × 24⅝″.

In this poster executed for Le Divan Japonais, "a little place like a provincial café, . . . able to seat at a pinch 150–200" (Yvette Guilbert, *Chanson de ma vie*), Lautrec included his first lithographic portrayals of the two Montmartre personalities for whom he felt genuine affection, Jane Avril and Yvette Guilbert. The willowy, splendidly drawn figure of Jane Avril dominates this most successful of Lautrec's early posters, while the exaggerated scrolls of the double basses direct our attention to the unmistakable black gloves of the singer onstage, Yvette Guilbert. Jane Avril's escort is Edouard Dujardin, a brilliant music critic, poet, novelist, aesthetic philosopher and founder of the *Revue Wagnérienne*. The presence of this distinguished and versatile Symbolist personality at Jane's side is a graceful reference to her intellectual companionability.

7. COUVERTURE DE L'ESTAMPE ORIGINALE. Lithograph printed in colors on wove paper with lettering for use as a cover, 1893 (W. 10 ii/ii; D. 17; A. 10). Signed in pencil by the artist, numbered from the edition of 100 impressions, and with the blindstamp of *L'Estampe originale*. 570 × 650 mm.; 22½ × 25⅝″.

Lautrec contributed two lithographic covers to *L'Estampe originale*, the print-publishing venture of André Marty that furnished subscribers three times each year from 1893 to 1895 with prints by most of Paris' leading artists. In this one he renders homage to two of the people he most admired, Père Cotelle and Jane Avril. Jane Avril, who complemented her dancing talents with tasteful admiration for Lautrec's prints, is shown examining proofs pulled by Cotelle, the master lithographer at Ancourt's lithography atelier, whom Lautrec relied upon for technical advice and precise printing.

Color plate A. JANE AVRIL. Lithograph printed in colors on wove paper with lettering for use as a poster, 1893 (W. 11 ii/iii; D. 345; A. 12). 1245 × 895 mm.; 49 × 35¼″.

This famous poster advertising Le Jardin de Paris shows the high-kicking performance of the dynamic Jane Avril (see No. 8) in the *quadrille naturaliste*, framed by the staff of the orchestra's bass fiddle. Vaucaire described the dance in the August 1, 1886, *Paris Illustré* as "that wonderful, insolent joke in which two women advanced side by side, each balancing on one foot while keeping the other at the level of the spectators' eyes. They wore silk stockings and cambric and lace drawers, with much swishing of pretty petticoats."

Color plate B. ARISTIDE BRUANT, DANS SON CABARET. Lithograph printed in colors on wove paper, 1893 (W. 14 i/ii; D. 348; A. 15). A proof of the first state before the addition of lettering for use as a poster. 1357 × 993 mm.; 53½ × 39⅛″. See No. 4.

8. JANE AVRIL. Lithograph printed in black on wove paper, 1893 (W. 17 i/iii; D. 28; A. 28). From the edition of 50 impressions of the first state before the addition of lettering, printed by Ancourt and published by L'Estampe originale in the *Café-Concert* album (with 11 lithographs by Toulouse-Lautrec, W. 17–27, and 11 by Henri-Gabriel Ibels). 265 × 213 mm.; 10½ × 8⅜″.

Jane Avril's unique and graceful style of dancing, which caused Charles Zidler to describe her as a "rapturous orchid," is here deftly captured by Toulouse-Lautrec's bold strokes, recalling the ink-brush drawings of Hokusai. The daughter of an Italian nobleman and a Parisian demimondaine, she endured a difficult childhood, which included a brief confinement in the Salpêtrière asylum. At 17, when the delusions of her abandoned mother became intolerable, Jane left home. On her first excursion to the Bal Bullier in the Latin Quarter, she discovered her love and aptitude for dance. There her innovative steps and revolutions elicited spontaneous applause from the spectators. Soon thereafter she was noticed at the Moulin-Rouge by Zidler, who offered her a position in the *quadrille* quartette (see color plate A) with La Goulue. Eventually, her distinctive gyrations—she was nicknamed "La Mélinite" for her high-explosive performances—brought her solo billing at both the Moulin-Rouge and the Jardin de Paris, where she matched her costume to the dance: black for the waltz, light blue for the polka and vermilion for the schottische. In later years Jane Avril was engaged by Lugné-Poë to interpret Anitra's Dance in his presentation of *Peer Gynt* at the Théâtre de l'Œuvre.

Always more detached from the brash vulgarity of Montmartre nightlife than the other dancers, Jane Avril seems to have evoked Lautrec's respect by her quiet self-sufficiency. In her memoirs, published in 1933 when she was 62, she, in turn, sympathetically described him as "a crippled genius whose witty and biting raillery must have helped him to conceal his profound melancholy."

9. MME ABDALA. Lithograph printed in black on wove paper, 1893 (W. 22; D. 33; A. 35). From the edition of 50 impressions printed by Ancourt and published by L'Estampe originale in the *Café-Concert* album. 273 × 203 mm.; 10¾ × 8″.

Mme Abdala was renowned for her comical interpretations of popular songs. Georges Montorgueil wrote of her: "She is endowed with an extraordinary scragginess. . . . In a grimacing competition . . . she would need to play no tricks in order to win the prize . . . her own face would win it for her. . . . She does all the things that nasty little girls who stick out their tongues, squint, make faces, and goggle

their eyes can think of. . . . She takes great pains to make herself ugly. . . . Under certain conditions of light and shadow Abdala, angular and with all her bony structure visible, suggests a drawing by Daumier."

10. CAUDIEUX — PETIT CASINO. Lithograph printed in black on wove paper, 1893 (W. 24; D. 35; A. 36). From the edition of 50 impressions, printed by Ancourt and published by L'Estampe originale in the *Café-Concert* album. 273 × 217 mm.; 10¾ × 8½".

As a comic singer at the Petit Casino celebrated for his broad humor and substantial paunch, Caudieux was described by Montorgueil as "a fat slob, well-fed, pot-bellied and good-natured . . . the king of shirkers." The same year, 1893, Lautrec executed a large poster for Caudieux, who also made appearances at L'Eldorado and Les Ambassadeurs.

11 & 12. Designs for song-sheet covers and their wrapper illustrating LES VIEILLES HISTOIRES, five poems by Jean Goudezki (Jean Goudey) with music by Désiré Dihau (published by G. Ondet), 1893 (W. 28–33; D. 18–23; A. 19–23, 25).

11. LES VIEILLES HISTOIRES, COUVERTURE-FRONTISPICE. Lithograph printed in olive-green on wove paper, 1893 (W. 28 iii/iii; D. 18; A. 19). Used as the wrapper for the song sheets. 338 × 546 mm.; 13¼ × 21½".

12a. NUIT BLANCHE. Lithograph printed in two colors on wove paper, 1893 (W. 30 ii/iii; D. 20; A. 21). Plate 2 of *Les Vieilles Histoires*. 257 × 171 mm.; 10⅛ × 6¾".

12b. ULTIME BALLADE. Lithograph printed in two colors on wove paper, 1893 (W. 33 ii/iii; D. 23; A. 22). Plate 5 of *Les Vieilles Histoires*. 265 × 181 mm.; 10⅜ × 7⅛".

As lithography became increasingly attractive as a medium for artistic expression in Paris during the 1880s, music publishers began commissioning artists to illustrate song sheets. These publishers would typically issue a limited edition of the lithographic image, before letters, for sale to collectors. By the mid-1890s they were also producing small editions of the covers with letters but without the accompanying music.

In 1893 the music publisher G. Ondet commissioned Lautrec to draw lithographs for use as covers for *Les Vieilles Histoires,* five popular, romantic songs by Désiré Dihau, with words by the poet Jean Goudezki. Dihau, a cousin of Lautrec's, was a bassoonist at the Opéra and was responsible for introducing the artist to Degas, whose work Lautrec idolized. Goudezki was given to singing his songs in a deep, solemn monotone that was, according to Adhémar, "irresistibly funny." The wrapper shows Dihau leading Goudezki, caricatured as a gentle trained bear, by the nose across Paris.

13. LE COIFFEUR — PROGRAMME DU THÉÂTRE LIBRE. Lithograph printed in colors, 1893 (W. 38 ii/iii; D. 14; A. 40). From the edition of 100 before lettering for use as the cover of a theater program. 316 × 240 mm.; 12½ × 9½".

Following this special printing of a collector's edition of 100 unlettered impressions, the program for the double bill of *Une Faillite* (*A Bankruptcy,* by the Norwegian playwright Björnstjerne Björnson), starring Théâtre Libre actor-manager André Antoine and the great actor Firmin Gémier, and *Le Poète et le Financier,* by Maurice Vaucaire, was printed in the upper left quadrant.

14. POURQUOI PAS? . . . UNE FOIS N'EST PAS COUTUME. Lithograph printed in olive-green on wove paper, 1893 (W.

42; D. 40; A. 43). Signed by the artist and numbered in pencil, from the edition of 100 impressions. 330 × 260 mm.; 13 × 10¼".

This print appeared in *L'Escarmouche* (The Skirmish), an ambitious but short-lived (November 1893 to March 1894) publishing project initiated by Georges Darien. It strove to reproduce three new designs by contemporary artists in each weekly issue. Lautrec supplied 12 lithographic drawings of scenes from Paris nightlife before the journal folded with its tenth issue. He titled each with the sober declaration, "J'ai vu ça" (I saw that), mimicking the grave observation (Yo lo vi) that Goya printed on a number of the plates of his *Disasters of War.* The single-sheet lithographs are in an edition of 100, most of which are signed and numbered.

In this lithograph, Lautrec presents a scene which could be observed nightly in the *promenoir* (lounge) of any dance hall: a man and a woman coolly appraising one another as possible companions for the night.

15. MLLE LENDER ET BARON. Lithograph printed in olive-green on wove paper, 1893 (W. 45 i/ii; D. 43; A. 46). Signed with the artist's red monogram stamp and numbered in pencil, from the edition of 100 impressions. 316 × 233 mm.; 12½ × 9⅛".

As Lautrec became more preoccupied with the world of theater, he discovered Marcelle Lender, a 30-year-old actress and singer then appearing at the Théâtre des Variétés. This is one of his first lithographic renditions of the popular Lender, whose beauty mesmerized the artist through 1895. She appears opposite Baron (Louis Bouchenez), a comic actor who acquired his nickname from his portrayal of Baron Gros in a revival of Jacques Offenbach's 1867 operetta *La Grande-Duchesse de Gérolstein.*

16. AU MOULIN-ROUGE: UN RUDE! UN VRAI RUDE! Lithograph printed in black on wove paper, 1893 (W. 47; D. 45; A. 48). Signed with the artist's red monogram stamp and numbered in pencil, from the edition of 100 impressions. 360 × 255 mm.; 14⅛ × 10".

The subtitle of this print, "Un Rude! Un vrai Rude!," is ambiguous. The central figure stroking his beard has been identified as Lautrec's father, a distinguished gentleman whose bearing Lautrec might well have likened to a sculpture by François Rude. Rude was celebrated in Paris for his vigorous high reliefs on the Arc de Triomphe de l'Etoile. It could be, however, that the men are comparing the young woman's profile to that of a Rude sculpture (less likely). Adhémar, on the other hand, has identified the white-bearded gentleman as the engraver Boetzel and "un rude" as a glass of *vin ordinaire* (perhaps brandy; this interpretation is even less likely because of the capital initial in "Rude"). Lautrec may well have intended some ironic double entendre involving the word *rude*, meaning a rough, unkempt or uncouth person.

17. BABYLONE D'ALLEMAGNE. Lithograph printed in colors on wove paper, 1894 (W. 56 ii/iii; D 351; A. 68). A proof before the lettering for use as a poster. 1200 × 820 mm.; 47¼ × 32¼".

This was the second poster Toulouse-Lautrec designed for a Victor Joze novel. Like the first, it created a stir. According to Joyant, the stiff arrogance of the mounted Prussian officer lampooned the German military. This offended the German ambassador and almost touched off an international incident.

18. LE PHOTOGRAPHE SESCAU. Lithograph printed in colors

with lettering for use as a poster, 1894 (W. 59 ii/iii; D. 353; A. 69). In the third state, Lautrec removed the mask from the model's face. 610 × 795 mm.; 24 × 31¼".

Lautrec regularly brought his models to the studio of his photographer friend, Paul Sescau, at 9 place Pigalle, and would later use Sescau's photographs as references for paintings. Sescau's reputation as a womanizer is confirmed by Lautrec's portrayal of him in *Promenoir* (see No. 77) and in this poster advertising both his photographic occupation and his phallic preoccupation.

19. LUGNÉ-POË DANS "AU-DESSUS DES FORCES HUMAINES." Lithograph printed in black on wove paper, 1894 (W. 60; D. 57; A. 62). Signed with the artist's red monogram stamp and numbered in pencil, from the edition of 50 impressions. Embossed with the oval blindstamp of the publisher, Kleinmann. 320 × 240 mm.; 12⅝ × 9½".

Aurélien-Marie Lugné-Poë (1870–1940) began his career as an actor in Antoine's Théâtre Libre, while sharing a studio with the painters Maurice Denis, Edouard Vuillard and Pierre Bonnard. In 1893 he founded the Théâtre de l'Œuvre, where he staged and directed France's first productions of Ibsen's plays *Rosmersholm* and *An Enemy of the People*. Lugné-Poë introduced the practice of dimming the house lights during a performance, an act that infuriated the Parisians, who clamored they were missing half the spectacle if they could not see one another! Lugné-Poë is depicted here opposite the Belgian actress Berthe Bady in a production of Björnstjerne Björnson's play *Beyond Our Powers*.

20. CECY LOFTUS. Lithograph printed in olive-green on *chine appliqué*, 1894 (W. 65; D. 116; A. 105). From the edition aggregating 35 impressions. 370 × 248 mm.; 14⅝ × 9¾".

Marie Cecilia (Cissie) Loftus was born in Glasgow in 1876. As a 17-year-old, she became known for her performances as a male impersonator at the Oxford Music Hall in London. In 1894 she exported her act to Paris, where Lautrec preserved for posterity her celebrated swagger and sneer. She later pursued a career in the legitimate theater in England and America, where she played several Shakespearean roles and a lead in *If I Were King*, a successful play written by her first husband, Justin Huntly M'Carthy.

21. MISS IDA HEATH — DANSEUSE ANGLAISE. Lithograph printed in olive-green on wove paper, 1894 (W. 66; D. 165; A. 104). Signed with the artist's red monogram stamp and numbered in blue pencil, from the edition aggregating 60 impressions. 360 × 261 mm.; 14⅛ × 10¼".

Ida Heath was an English dancer whose angular features attracted Lautrec enough to secure a place in a second lithograph the same year, *Ida Heath au bar.*

22. BRANDÈS ET LE BARGY, DANS "CABOTINS." Lithograph printed in olive-green on wove paper, 1894 (W. 69; D. 61; A. 65). Signed with the artist's red monogram stamp and numbered in pencil, from the edition of 50 impressions. Embossed with the oval blindstamp of the publisher, Kleinmann. 428 × 332 mm.; 16⅞ × 13⅛".

Marthe Brandès, née Marthe Brunschwig, achieved some notoriety by fainting at a performance by Sarah Bernhardt. She played at the Comédie-Française from 1893 to 1903. Her distinctive profile was irresistible to Lautrec, who portrayed her in two other lithographs. Here she is shown opposite Charles Le Bargy in the 1894

production of Edouard Pailleron's *Cabotins* (*Charlatans*). Le Bargy, then 38, was noted for his exquisite good looks and sartorial perfection. One reviewer remarked that although he showed little dramatic talent, he could have pursued a brilliant career in the diplomatic service.

23. LA LOGE AU MASCARON DORÉ — PROGRAMME POUR "LE MISSIONNAIRE." Lithograph printed in colors with lettering on wove paper, 1894 (W. 71 iii/iii; D. 16; A. 72). From the edition used as the cover for a theater program. 307 × 241 mm.; 12 × 9½".

Inspired by a painting of 1880 by Degas, the *Loge au Théâtre*, Lautrec contributed this cover for the program of *Le Missionnaire* by Marcel Luguet, which opened May 5, 1895, at the Théâtre Libre. Lautrec's friend, the English painter Charles Conder, escorts the well-tailored woman in the gilded box.

Color plate C. AUX AMBASSADEURS. Lithograph printed in colors on wove paper, 1894 (W. 72 ii/ii; D. 68; A. 73). Signed in pencil and embossed with the blindstamp of L'Estampe originale, from the edition of 100 impressions. 302 × 246 mm.; 11⅞ × 9⅝".

Les Ambassadeurs was one of the most elegant of the *café-concerts* on the Champs-Elysées, a particularly pleasant spot in summer, where the performers sang from a covered stage to the audience seated below. In this most delicate of Lautrec's color lithographs, the artist has effectively conveyed the magical suspension of the lighted stage bearing its pink cloud of a *chanteuse* against the deep blue summer night.

24. CARNAVAL. Lithograph printed in black on wove paper, 1894 (W. 76 i/iii; D. 64; A. 42). One of a few impressions of the first state, with large margins. The second state is printed in olive-green with red for the lips, and was published in the June 1894 issue of *La Revue Blanche*. 273 × 205 mm.; 10¾ × 8⅛".

When the *Revue Blanche* announced it would include original prints in certain of its issues, Lautrec submitted this lithograph of two extravagantly costumed and painted merrymakers. Thadée Natanson has related Lautrec's delight at having obtained an extra stone "simply for the double accent of vermilion that parts the lips of a single figure."

25–28. From: ALBUM "YVETTE GUILBERT," TEXTE DE GUSTAVE GEFFROY, ORNÉ PAR H. DE TOULOUSE-LAUTREC. Sixteen lithographs printed in olive-green (the cover in black) on laid paper, 1894 (W. 77–93; D. 79–95; A. 86–103; The Artist and the Book 301; Rauch 14). Signed in green crayon by Yvette Guilbert and typographically numbered from the edition of 100. Published by L'Estampe originale, Paris. 390 × 385 mm.; 15⅜ × 15⅛".

Born in 1868, Yvette Guilbert began her career at 15 as a mannequin. A fortuitous encounter two years later with the drama critic Edmond Stoullig enabled her to study acting and singing, and for the next few years she obtained minor roles in small theaters. Realizing that her voice was not strong enough for opera but was ideally suited to the *café-concert,* where the successful performer could be certain of a healthy salary, Yvette resolved to develop a style and an image that would ensure her success. Her initial engagement at L'Eldorado in 1889 was a disappointing failure, but after two successful seasons at the Eden-Concert, during which Yvette refined her repertoire and her appearance, which emphasized her red hair, white skin, round eyes and long flexible neck, she was featured

regularly at the Moulin-Rouge and the Divan Japonais.

Yvette Guilbert was seen by many writers of the period as the muse of the *fin-de-siècle* period, at once tragic and comic, vulgar and refined. She was called a *diseuse*, a reciter of songs whose tones ranged, according to one observer, from "the sweetest, most delicious melody to strident hoarse cries of passion and grief or the gutter voice of the Parisian *canaille*." Her ability to captivate any audience, from the most sophisticated to the most common, lay in her flawless diction and her remarkable delivery, which consisted of standing virtually motionless while singing.

Lautrec first encountered Yvette Guilbert in July 1894, when he offered to design a poster for her. She rejected his drawing, which is now in the Musée d'Albi, in favor of a more flattering design by Steinlen. Expressing dismay at Lautrec's sketch, she wrote, ". . . for the love of Heaven don't make me so atrociously ugly! Just a little less! A great many people who have been here screamed like savages at the sight of the colored sketch." When she queried why he continued to use her as a model when he seemed only to caricature her, he replied, "because you amuse me, you inspire me—with your extreme distinction in farce, the vinegar of your smile, the grain of pepper in your little eye and the astonishing ingenuity of your costume."

The publication of this *édition de luxe*, celebrating the low-brow world of the *café-concert* with a sensitive essay by Gustave Geffroy and Lautrec's brilliant lithographs, met with much acclaim. Georges Clemenceau wrote, "One draws, the other speaks; together they have extracted from the *café-concert* a high expression of art and thought." Yvette Guilbert's friends resented Lautrec's lithographs (Jean Lorrain complained to her about allowing Lautrec to "make pictures of you with goose-shit"—possibly a reference to the greenish tinge of the ink in this series), but after receiving the book she wrote to Lautrec, "Cher ami, thank you for your lovely drawings for the book by Geffroy. I am delighted! delighted! and you have all my gratitude, believe me."

25. YVETTE GUILBERT (5th plate). Lithograph printed in olive-green on wove paper, 1894 (W. 82 i/ii; D. 84; A. 91). One of the few impressions of the first state before the text. 305 × 255 mm.; 12 × 10".

Toulouse-Lautrec portrays her in a demure attitude, the sprinkling of *crachis* behind her head perfectly evoking the smoky, gaslit atmosphere of the *café-concert*.

26. YVETTE GUILBERT (7th plate). Lithograph printed in olive-green on wove paper, 1894 (W. 84 i/ii; D. 86; A. 93). One of the few impressions of the first state before the text. 275 × 155 mm.; 10⅞ × 6⅛".

27. YVETTE GUILBERT (11th plate). Lithograph printed in olive-green on wove paper, 1894 (W. 88 i/ii; D. 90; A. 97). One of the few impressions of the first state before the text. 373 × 152 mm.; 14⅝" × 6".

"My nose, somewhat heavy, was a boon to the caricaturists. It delighted them to draw it with a lumpy outline as if two cherrystones had been stuffed into it. My nose was really rather quaint with its little rounded tip, but this was only due to a slight excess of fleshiness. . . . I would not for the world in my early days have improved that nose-end! It gave an excuse for the impertinent drawings of famous draughtsmen, and the publicity was as valuable to the actress as it was to the cartoonists. What they did with my lumpy nose and my long neck is simply unbelievable." (Yvette Guilbert, *Chanson de ma vie*.)

28. YVETTE GUILBERT (12th plate). Lithograph printed in olive-green on wove paper, 1894 (W. 89 i/ii; D. 91; A. 98). One of the few impressions of the first state before the text. 368 × 269 mm.; 14½ × 10⅝".

It has been observed that Guilbert affected "a genial cynicism . . . a curious intermingling of pathos and humor, and so when she weeps, it is with laughter on her lips, and when she smiles, she smiles through a mist of tears."

29. LA GOULUE. Lithograph printed in black on wove paper, 1894 (W. 99 i/ii; D. 71; A. 77). Signed by the artist in pencil and with the artist's red monogram stamp, from the edition of 100 impressions before letters published by Kleinmann. 308 × 253 mm.; 12¼ × 10".

Later used as the cover for a waltz written by Bosc and named for La Goulue, this exquisitely drawn lithograph was Toulouse-Lautrec's last depiction of the famous pair (see No. 1), here shown arching in a graceful waltz, a departure from their customary frenzied activity. Valentin le Désossé, who ran a small café in the rue Coquillière, danced in Montmartre for the sheer pleasure of it. He accepted no salary, preferring to maintain his dual identity as a businessman during the day and an inspired amateur in the evenings, so much so that an habitué of the Moulin-Rouge, Paul Leclercq, wrote of the etiquette concerning Valentin, "In the daytime we did not greet him, and he did not solicit recognition." Nevertheless, his extraordinary elasticity as a dancer made him the most memorable male performer of the era. Gustave Coquiot has described his remarkable style: "His tall, thin figure resembled that of a lamppost; he might have been any any age from 35 to 55, had close-cropped hair like a corporal, looked all skin and bone and was certainly mounted on springs. He was something like a monkey and something like an opossum. . . . But this gawk of a man could waltz at an incredible speed and with impeccable rhythm. His large feet, lifted each time at precisely the same angle, revolved like automata. What a genius he was." The sympathetic bond that existed between Valentin and La Goulue and enabled them to perform as such fine complements to one another, also extended into their quiet hours, when they were frequently to be seen as fishing companions, or weeding the flower gardens which La Goulue tended devotedly.

30. ANNA HELD, DANS "TOUTES CES DAMES AU THÉÂTRE." Lithograph printed in black on wove paper, 1894 (W. 103 ii/ii; D. 100; A. 112). As published in *NIB*, a special supplement to *La Revue Blanche*. 320 × 218 mm.; 12⅝ × 8⅝".

31. FOOTIT ET CHOCOLAT. Lithograph printed in black on wove paper, 1894 (W. 104 ii/ii; D. 98; A. 108). As published in *NIB*, a special supplement of *La Revue Blanche*. 196 × 245 mm.; 7¾ × 9⅝".

Lautrec encountered the intellectual and artistic circle of the *Revue Blanche* (see No. 33) in early 1894 through his friends, the poet Paul Leclercq and the lascivious writer Romain Coolus. In January 1895 Lautrec and Tristan Bernard collaborated on the first of three supplements to the *Revue Blanche*, entitled *NIB* (slang for "nothing doing"), which contained breezy information and offbeat ads.

One of Lautrec's lithographs portrays the singer Anna Held, celebrated for her alluring almond-shaped eyes, coquettish glances, extravagant dresses and hats and American and English songs. She later performed in England and America, and she died in New York in 1918. (The "Miam, Miam, Miam" on the print is the French equivalent of "yum, yum.") Another lithograph, advertising Potin's chocolate, shows the English clown George Footit giving the boot to his partner Chocolat. The pair performed at the Nouveau Cirque in Paris.

32. COUVERTURE DE L'ESTAMPE ORIGINALE. Lithograph printed in colors on wove paper, 1895 (W. 107 iii/iii; D. 127; A. 111). One of the few surviving impressions of an *épreuve de passe* (approval proof), signed and designated "*passe*" by the artist in black crayon. Ex coll.: Ludwig & Erik Charell. 590 × 830 mm.; 23¼ × 32⅝″.

In his cover design for the final issue of *L'Estampe originale*, Lautrec expressed his new familiarity with the backstage world. Having been engaged by Lugné-Poë earlier in the year to design the sets and program for *Le Chariot de Terre Cuite* (the Sanskrit play *The Little Clay Cart*), Lautrec recreated the opening-night scene from two perspectives. As the workmen labor to raise the curtain backstage, Misia Natanson leans forward expectantly from the graceful contours of her box, and the cover image becomes a metaphor for the anticipation felt by the subscriber opening the *Album de clôture* of *L'Estampe originale*.

33. LA REVUE BLANCHE. Lithograph printed in colors on wove paper with lettering for use as a poster, 1895 (W. 108 iii/iii; D. 355; A. 115). 1290 × 930 mm.; 50¾ × 36⅝″.

La Revue Blanche was an eclectic journal of arts and letters founded in December 1889 by the brothers Natanson (Alexandre, Louis-Alfred and Thadée) and the poet Paul Leclercq. The periodical was distinguished by its left-wing political slant and ribald, avant-garde fiction and illustration. The circle of contributors soon included the writers Stéphane Mallarmé, Paul Valéry, Alfred Jarry, Emile Zola, Marcel Proust and the young Colette, and the painters Pierre Bonnard, Edouard Vuillard and Félix Vallotton. The center around whom all these literary and artistic figures revolved was Misia, then the wife of Thadée, a captivating young woman of Polish origin who possessed sufficient poise to conduct the most celebrated salon of avant-garde Paris while still in her early twenties. Lautrec's portrayal of her, turned out in a magnificent costume, gliding swiftly along on unseen ice skates, effectively conveys her sophisticated presence.

34. CONFETTI. Lithograph printed in colors on wove paper for use as a poster, 1895 (W. 109 ii/ii; D. 352; A. 9). 574 × 447 mm.; 22⅝ × 17⅝″.

This cheerful poster was commissioned by the London firm J. & E. Bella, manufacturers of confetti, which was available in Paris only on the black market after being banned following the 1892 Mardi Gras. British and American companies soon recognized Lautrec's distinctive talents as a poster designer, and he received numerous commissions.

35. LENDER DE DOS, DANSANT LE BOLÉRO DANS "CHILPÉRIC." Lithograph printed in olive-green on wove paper, 1895 (W. 114; D. 106; A. 127). Signed with the artist's red monogram stamp and numbered in pencil, from the edition of 50 impressions. Embossed with the blindstamp of the publisher, Kleinmann. 375 × 265 mm.; 14¾ × 10⅜″.

Marcelle Lender was an actress and singer celebrated for her beauty and grace. In Nos. 35–37 Lautrec records moments in her acclaimed performance as the Visigoth princess Galswintha in *Chilpéric*, an 1868 operetta by Hervé revived in February 1895 at the Théâtre des Variétés. Lautrec was captivated by Lender. In 1931 his friend the poet, journalist and playwright Romain Coolus wrote that during the winter of 1895–1896 Lautrec dragged him to *Chilpéric* no less than twenty times: "When I grew a little weary of hearing the famous chorus . . . I asked Lautrec why he made a point of subjecting me to such mundane music night after night. 'I come only to see Lender's back,'

he replied. 'Look at it carefully; you will never see anything so magnificent.'" Marcelle Lender was the only model whom Toulouse-Lautrec did not caricature, and he drew her portrait on stone eleven times.

36. LENDER DANSANT LE PAS DU BOLÉRO, DANS "CHILPÉRIC." Lithograph printed in olive-green on wove paper, 1895 (W. 115; D. 104; A. 128). Signed with the artist's red monogram stamp and numbered in pencil, from the edition of 50 impressions. Embossed with the blindstamp of the publisher, Kleinmann. 366 × 265 mm.; 14⅜ × 10⅜″.

37. LENDER DE FACE, DANS "CHILPÉRIC." Lithograph printed in gray-green on wove paper, 1895 (W. 116; D. 105; A. 129). Signed with the artist's red monogram stamp and numbered in pencil, from the edition of 25 impressions. Embossed with the blindstamp of the publisher, Kleinmann. 370 × 263 mm.; 14½ × 10⅜″.

38. MLLE MARCELLE LENDER, EN BUSTE. Lithograph printed in eight colors on wove paper, 1895 (W. 118 iv/b; D. 102; A. 131). As published in the German fine-art journal *Pan* (Vol. I, No. 3), in an edition of about 1200 impressions. With the typographic text: "*Originallithographie in acht Farben von H. de Toulouse-Lautrec.*" 325 × 245 mm.; 12¾ × 9⅝″.

39. MLLE MARCELLE LENDER, DEBOUT. Lithograph printed in four colors on laid paper, 1895 (W. 119 ii/ii; D. 103; A. 134). Signed by the artist and numbered in pencil, from the edition of only 12 impressions in color. 358 × 238 mm.; 14⅛ × 9⅛″.

In comparison to the preceding rendition of Mlle Lender, the coloring of this print is subtle and warm, in keeping with the tonal range of Lautrec's paintings of this period.

40. LENDER ET AUGUEZ, DANS "LA CHANSON DE FORTUNIO." Lithograph printed in gray-green on wove paper, 1895 (W. 123; D. 108; A. 138). Signed with the artist's red monogram stamp and numbered in pencil, from the edition of 20 impressions. Embossed with the blindstamp of the publisher, Kleinmann. 370 × 215 mm.; 14½ × 7½″.

In this new production of Offenbach's 1861 operetta *La Chanson de Fortunio*, Marcelle Lender played opposite Numa Auguez of the Opéra.

41. LUCE MYRÈS, DE FACE. Lithograph printed in olive-green on wove paper, 1895 (W. 125; D. 125; A. 139). A proof apart from the small edition of 20 impressions. 353 × 240 mm.; 13⅞ × 9½″.

Luce Myrès was a popular café *chanteuse*, and Lautrec portrayed her in a profile view (W. 124) as well. Here she faces the footlights in a revival of Offenbach's 1868 operetta *La Périchole* at the Théâtre des Variétés.

42. YAHNE ET ANTOINE, DANS "L'AGE DIFFICILE." Lithograph printed in black on heavy wove paper, 1895 (W. 128; D. 112; A. 117). Signed in pencil, from the edition of 25 impressions. 350 × 258 mm.; 13¾ × 10⅛″.

The actress Léonie Yahne here appears with André Antoine in his 1895 production of Jules Lemaître's comedy *L'Age Difficile*. The noted actor Antoine, who in 1887 co-founded the Théâtre Libre and in 1906 became director of the Odéon, was, according to Arthur Symons, "ugly, with no good features, no profile, a large nose, a receding chin, bright, unflinching eyes, and a mobile, typical actor's

face. . . . He had enthusiasm and judgment; he was vivid, impressionable, reflective." Antoine staged *L'Age Difficile* at the Gymnase, since he was then negotiating the sale of the Théâtre Libre. The play was a hit and financially profitable.

43. MAY BELFORT. Lithograph printed in colors on wove paper with lettering for use as a poster, 1895 (W. 136 iv/v; D. 354; A. 116). 795 × 610 mm.; 31¼ × 24".

A pretty Irish singer of old songs and ballads who fancied Kate Greenaway dresses, puffed sleeves and a ruffled mob cap surmounted by a large bow, May Belfort was probably seen by Lautrec in 1895 at Les Décadents, a noisy, picturesque *café-concert*. She often cradled a black cat in her arms while she sang; as Coquiot recalled, "This bleating ewe in baby costume, with ringlets tumbling over her shoulder . . . held a black kitten in her arms and sang, 'I've got a little cat, and I'm very fond of that . . . ,' while the audience would shout the chorus." (The song in question is the famous 1892 English music-hall number "Daddy Wouldn't Buy Me a Bow-Wow," words and music by Joseph Tabrar.)

44. MAY MILTON. Lithograph printed in colors on wove paper with lettering for use as a poster, 1895 (W. 138 iii/iii; D. 356; A. 149). 785 × 610 mm.; 30⅞ × 24".

Joyant has described the face of May Milton, an English dancer, as "pale, almost clown-like . . . rather like that of a bulldog." The French dancer Jane Avril befriended her English colleague and introduced her to the circle that included Toulouse-Lautrec. Lautrec's poster captures the supple, strong-jawed dancer in full kick.

Color plate D. NAPOLÉON. Lithograph printed in colors on wove paper, 1895 (W. 141; D. 358; A. 150). Signed in pencil by the artist, and numbered from the edition of 100. 582 × 453 mm.; 23 × 17⅞".

This lithograph of Napoleon flanked by a uniformed marshal and a robed Mameluke originated as Lautrec's entry in a competition for a poster to advertise a new biography of the Emperor. Twenty-one artists vied for a 1000-franc prize. The jury, composed of academicians Jean-Léon Gérôme, Jehan-Georges Vibert and Edouard Detaille, spurned Lautrec's design in favor of three others. After another biographer of Napoleon rejected the image, the artist had 100 impressions printed at his own expense.

45. IRISH AND AMERICAN BAR, RUE ROYALE — THE CHAP BOOK. Lithograph printed in colors with lettering on wove paper for use as a poster, 1895 (W. 143 iii/iii; D. 362; A. 189). 417 × 600 mm.; 16⅜ × 23⅝".

This poster advertising *The Chap Book*, an American magazine, depicts the interior of the Irish and American Bar in the rue Royale, a haunt frequented by racetrack personalities and many of the characters appearing in Lautrec's lithographs. We see Ralph, the impassive bartender of Chinese and American Indian descent, and two other habitués: liveried coachmen relaxing off-duty while their employers dined in some expensive restaurant of the quarter. The Irish and American Bar was Lautrec's favorite watering hole outside Montmartre. He would sit in a small room at the back and scrutinize the cocktail-hour crowd.

46. LA PASSAGÈRE DU 54 — PROMENADE EN YACHT. Lithograph printed in colors on wove paper for use as a poster, 1895 (W. 145 iii/iii; D. 366; A. 188). 610 × 446 mm.; 24 × 17½".

This poster was used to announce the opening of the

Exposition Internationale d'Affiches (International Poster Exhibition) at the Salon des Cent gallery in 1896. Lautrec made the preparatory sketches while on his annual sea cruise from Le Havre to Bordeaux. Apparently he was so smitten by his fellow passenger from Cabin 54, a woman voyaging to Dakar, that he refused to leave the ship at Bordeaux and only reluctantly disembarked at Lisbon!

47–50. Four designs for song-sheet covers illustrating 14 MÉLODIES DE DÉSIRÉ DIHAU, DE L'OPÉRA, with lyrics by Jean Richepin, published by C. Joubert, 1895 (W. 147–160; D. 129–142; A. 151–159, 161–165):

47. ADIEU. Lithograph printed in turquoise on China paper, 1895 (W. 147 ii/ii; D. 129; A. 158). As published in *Quatorze lithographies originales de Toulouse-Lautrec pour illustrer des chansons.* 239 × 193 mm.; 9⅜ × 7⅝".

48. LES PAPILLONS. Lithograph printed in black ink on wove paper, 1895 (W. 151 ii/ii; D. 133; A. 154). An early impression of the *Mélodies* song sheet without a printer's address. 211 × 195 mm.; 8¼ × 7⅝".

49. BERCEUSE. Lithograph printed in turquoise on China paper, 1895 (W. 159 ii/ii; D. 141; A. 152). As published in *Quatorze lithographies originales de Toulouse-Lautrec pour illustrer des chansons.* 242 × 205 mm.; 9½ × 8".

50. LES VIEUX PAPILLONS. Lithograph printed in black on wove paper, 1895 (W. 160 ii/ii; D. 142; A. 162). An early impression of the *Mélodies* song sheet without a printer's address. 235 × 195 mm.; 9¼ × 7⅝".

Recalling the success of the earlier series of song sheets published by Ondet (Nos. 11 & 12), songwriter Dihau persuaded the publisher Joubert to substitute designs by Lautrec for those originally commissioned from another artist.

As a dessert to cap a sumptuous dinner, Lautrec once led his guests, including the artist Edouard Vuillard, to Dihau's apartment three flights up on the rue Frochot. "Barely stopping to greet the Dihaus," Vuillard recalled, he led us up to Degas's painting, *Dihau Playing in the Orchestra at the Opéra,* and said, "There you are—that's the dessert!"

51. LA VALSE DES LAPINS. Lithograph printed in black on wove paper, 1895 (W. 162 i/ii; D. 143; A. 160). With the artist's red monogram stamp, from the small edition before lettering for use as a song-sheet cover. 315 × 235 mm.; 12⅜ × 9¼".

Four years after designing this song-sheet cover for Bosc, Lautrec again lovingly portrayed rabbits in the grass as an illustration for the *Histoires Naturelles* (see Nos. 78 & 79).

52. LA TROUPE DE MLLE EGLANTINE. Lithograph printed in colors on buff wove paper for use as a poster, 1896 (W. 165 iii/iii; D. 361; A. 198). 625 × 806 mm.; 24⅝ × 31¾".

This poster advertises the appearance of the troupe—composed of (left to right) Jane Avril, Cléopâtre, Eglantine and La Gazelle—at the Palace Theatre in London, following their successful performance of a *quadrille* at the Casino de Paris.

53. PROCÈS ARTON — DÉPOSITION RIBOT. Lithograph printed in black on wove paper, 1896 (W. 171; D. 192; A. 193). Signed with the artist's red monogram stamp. One of a few impressions published by Kleinmann. 460 × 555 mm.; 18⅛ × 21⅞".

Léopold-Emile Aron (Arton) was a broker and agent

accused of bribing a government official in connection with events surrounding the bankruptcy of the Panama Company in 1880. Arton fled France, was extradited from England in 1895 and stood trial in 1896 in Paris. Lautrec sketched various witnesses giving testimony at the trial and redrew the courtroom drama on stone.

54–60 (and color plate E). From: ELLES. A series of ten lithographs with a frontispiece, each printed in colors on crisp wove paper, published by Gustave Pellet in an edition of 100 impressions, 1896 (W. 177–187; D. 179–189; A. 200–210). Each is printed without margins to the deckle edges of the sheet of paper, which is watermarked "G. Pellet/T. Lautrec."

The *Elles*, save one, are occupants of various Paris brothels, where Lautrec took up residence from time to time between 1892 and 1895. He acquaints us uncritically with the domestic routines of his intimates. We see them at ease, resting, grooming, washing, dressing. There is little hint of a sordid environment or their seamier tasks.

"Lautrec kept very odd company," Edouard Vuillard recalled when interviewed in 1931. "But the real reasons for his behavior were moral ones. . . . Lautrec was too proud to submit to his lot, as physical freak, an aristocrat cut off from his kind by his grotesque appearance. He found an affinity between his own condition and the moral penury of the prostitute." Lautrec himself once commented ironically that among prostitutes "j'ai trouvé des femmes à ma taille" (I have found women at my level).

Yvette Guilbert once asked Lautrec frankly whether he lived in a house of prostitution to hide from his creditors. He burst out laughing and replied that he lived in a brothel in order to "comprehend prostitution and . . . to understand the sentimental anguish of the poor creatures, servants of Love. He was their friend, their adviser, their consoler, never their judge." (Yvette Guilbert, *Chanson de ma vie*.)

As Jean Adhémar has written, "the notion that the *fille* is a woman like any other, and that her life is very simple, was very dear to Lautrec. He insisted on the point at length in conversations with friends, and he came back to it at every opportunity. The title alone of the *Elles* suite nicely conveys his conception, for in the literature of the times the word *Elles* connotes all women; for him woman thus embodies the ones that he pictures here. When he entered the fashionable world, at a dance on the rue de la Faisanderie for example, he said to a friend: 'My friend, being here is like being in a brothel.'"

54. FRONTISPICE POUR: ELLES. Lithograph printed in colors on wove paper with red lettering for use as a poster by Pellet to advertise the exhibition of the *Elles* at La Plume gallery, 1896 (W. 177 iii/iii; D. 179; A. 200). 645 × 495 mm.; 25⅜ × 19½".

Color plate E. CLOWN — LA CLOWNESSE ASSISE — MLLE CHA-U-KA-O. Lithograph printed in colors, 1896 (W. 178 ii/ii; D. 180; A. 201). Plate 1 of *Elles*, either a trial proof, an *épreuve de passe* apart from the edition or an unnumbered impression.

Mlle Cha-U-Ka-O, though included as an *Elle* in this series, was no prostitute but a popular performer at the Moulin-Rouge. Her name was an orientalization of *Chahut-chaos*, the name of a highly energetic exhibition dance.

55. FEMME AU PLATEAU — PETIT DÉJEUNER — MME BARON ET MLLE POPO. Lithograph printed in sanguine, 1896 (W. 179; D. 181; A. 202). Plate 2 of *Elles*, with Pellet's *paraphe* (logo initials) and number in ink, as well as his stamp (Lugt 1190). 404 × 528 mm.; 15⅞ × 20¾".

Mme Juliette Baron was the *propriétaire* of one of Lautrec's favorite brothels in the rue des Moulins. Here she removes the breakfast tray from the bed of her daughter Paulette, Mlle Popo.

56. FEMME COUCHÉE — RÉVEIL. Lithograph printed in dark olive-green, 1896 (W. 180; D. 182; A. 203). Plate 3 of *Elles*, with Pellet's *paraphe* and number in ink, and with his stamp (Lugt 1190). 403 × 520 mm.; 15⅞ × 20½".

57. FEMME AU TUB — LE TUB. Lithograph printed in colors, 1896 (W. 181; D. 183; A. 204). Plate 4 of *Elles*, either a trial proof, an *épreuve de passe* apart from the edition or an unnumbered impression. 404 × 522 mm.; 15⅞ × 20½".

58. FEMME QUI SE LAVE — LA TOILETTE. Lithograph printed in olive-green and blue, 1896 (W. 182 ii/ii; D. 184; A. 205). Plate 5 of *Elles*, either a trial proof, an *épreuve de passe* apart from the edition or an unnumbered impression.

59. FEMME QUI SE PEIGNE — LA COIFFURE. Lithograph printed in brown-violet on a green-gray tone plate, 1896 (W. 184 ii/ii; D. 186; A. 207). Plate 7 of *Elles*. 527 × 405 mm.; 20¾ × 16".

60. FEMME EN CORSET — CONQUÊTE DE PASSAGE. Lithograph printed in colors, 1896 (W. 186 ii/ii; D. 188; A. 209). Plate 9 of *Elles*, stamped with the artist's monogram in blue, and with Gustave Pellet's *paraphe* and number in ink. 528 × 404 mm.; 20¾ × 15⅞".

A study for this lithograph in the Musée des Augustins in Toulouse depicts as the gentleman caller Lautrec's friend, Charles Conder, the English painter and engraver who resided in Paris from 1890 to 1894.

61. DÉBAUCHE. Lithograph printed in colors with lettering on wove paper for use as pictorial wrappers for a catalogue, 1896 (W. 191 ii/ii; D. 178; A. 212). 236 × 320 mm.; 9¾ × 12⅝".

The indifferent woman is some unidentified resident of a *maison close*; the lecherous man, Maxime Dethomas, one of Lautrec's pals, a *peintre-graveur* and stage designer known best for his work overseeing the decorations for the Théâtre National de l'Opéra. Lautrec nicknamed him "Grosnarbre" for his deadpan face; Natanson described him as a gentle giant, polished and discreet. This sheet served as a cover for a sales catalogue of posters by French and foreign artists offered by Arnould, 7 rue Racine.

62. SORTIE DE THÉÂTRE. Lithograph printed in black on wove paper, 1896 (W. 204; D. 169; A. 218). A proof aside from the recorded edition of 25 numbered impressions. 314 × 260 mm.; 12⅜ × 10¼".

Lautrec would often accompany his housemates of the Paris demi-monde to public places. Here the madame of a rue des Moulins brothel, whom Lautrec sometimes dated himself, returns with her escort from an evening at the theater.

Color plate F. IDYLLE PRINCIÈRE. Lithograph printed in colors on China paper, 1897 (W. 207 ii/ii; D. 206; A. 230). Signed in pencil by the artist, numbered from the edition of only 16 impressions, and with the red stamp of the publisher, Gustave Pellet. 374 × 280 mm.; 14¾ × 11".

Lautrec here portrays the subjects of one of the society scandals of 1897. Clara Ward, the daughter of a Detroit

millionaire who was married at 18 to the Prince de Caraman-Chimay, ran away six years later with a gypsy named Rigo. Lautrec shows the new couple in their theater box: Clara gazes toward the stage, while Rigo only has eyes for her. Although she married him in 1904, she soon left him for another lover. Clara Ward died in Padua in 1916.

63. A LA SOURIS — MADAME PALMYRE. Lithograph in dark violet on China paper, 1897 (W. 210 ii/ii; D. 210; A. 252). Signed in pencil by the artist, and numbered from the edition of 25 impressions. 355 × 249 mm.; 14 × 9¾″.

Like Le Hanneton (see No. 76), La Souris (The Mouse) was a Montmartre café that catered to a lesbian clientele. The proprietress was Madame Palmyre, described by Paul Leclercq as "a buxom woman with the ferocious appearance of a bulldog who, though in reality exceedingly kindhearted, always seemed to be on the point of biting." Mme Palmyre kept a dog that reflected her features, the bulldog Bouboule, who, it is told, urinated on the ankles of those among his mistress' clientele imprudent enough to fondle him.

64. LA PETITE LOGE. Lithograph printed in colors on China paper, 1897 (W. 212 ii/ii; D. 209; A. 257). Signed in pencil by the artist, and numbered from the edition of only 12 impressions. 267 × 354 mm.; 10½ × 14″.

Color plate G. PARTIE DE CAMPAGNE. Lithograph printed in colors on wove paper to the edges of the sheet, 1897 (W. 216 iii/iii; D. 219; A. 322). Signed with the artist's red monogram stamp and numbered in pencil, from the edition of 100 impressions published by Ambroise Vollard in the second Album des Peintres-Graveurs.

The elegantly dressed passengers are Charles Conder (see No. 60) and Misia Natanson (see Nos. 32 & 33). This refreshing departure by Lautrec from his Montmartre cafés, brothels and carbarets is one of the few evocations of the countryside of his youth. There is in fact no picture by Lautrec so bright and airy as this outing in the country.

65. COUVERTURE POUR "LES COURTES JOIES." Lithograph printed in gray-black with a beige tone plate on China paper, 1897 (W. 237 ii/ii; D. 216; A. 228). From the edition published by Frapier, 1925. 180 × 251 mm.; 7⅛ × 9⅞″.

The book for which this lithograph served as pictorial wrappers contained 115 poems by Julien Sermet, with a preface by Gustave Geffroy. It was published by Joubert in Paris, April 26, 1897.

66. HOMMAGE À MOLIÈRE. Lithograph printed in brown, with the letters "Hors les Lois," on wove paper for use as a book cover, 1897 (W. 240 iii/iii; D. 220; A. 272). 228 × 211 mm.; 9 × 8¼″.

This lithograph was used as pictorial wrappers for the text of Hors les Lois, a verse comedy in one act presented November 5, 1897, at the Théâtre Antoine. It shows two actors in eighteenth-century costume and a couple in contemporary dress before the bust of Molière in the Théâtre. In an earlier state the lithograph served, with different lettering, as the program accompanying the playbill.

67–70. From: YVETTE GUILBERT DRAWN BY HENRI DE TOULOUSE-LAUTREC (SÉRIE ANGLAISE). Suite of eight lithographs printed in black on a beige tone plate on rough-grained Holland paper, 1898 (W. 255–264 ii/iii; D. 250–255, 257–260; A. 306–311, 313–315). As published by Bliss & Sands, London, with lithographic cover, title page and eight plates, in an edition of 350 impressions.

This is the second album that Lautrec composed for the great chanteuse Yvette Guilbert (see Nos. 25–28). The portraits are drawn on the stone with a very light touch. "These," asserts André Fermigier, "are all works of genius and are among the best he ever did."

Guilbert was a shrewd, talented woman who calculatingly created a distinctive stage presence. In her autobiography, Chanson de ma vie (English translation, 1929), she observed, "Owing to the strongly marked silhouette of my early days, French writers and those of other countries who were kind enough to talk about me said that I was 'a living, death-like poster.' That was just what I intended. Neck very long and slender, very round, very lithe; sloping shoulders, no bosom, waist just under twenty-one inches; hips, very long legs, which people imagined to be thin (but they were wrong!), for I was une fausse maigre, and long arms that looked even thinner in their long black gloves up to the shoulder."

67. YVETTE GUILBERT — SUR LA SCÈNE. Lithograph in black, 1898 (W. 257 ii/iii; D. 252; A. 308). 299 × 238 mm.; 11¾ × 9⅜″.

68. YVETTE GUILBERT — PRESSIMA. Lithograph in black, 1898 (W. 259 ii/iii; D. 254; A. 310). 265 × 236 mm.; 10⁷⁄₁₆ × 9¼″.

69. YVETTE GUILBERT — CHANSON ANCIENNE. Lithograph in black, 1898 (W. 261 ii/iii; D. 257; A. 313). 295 × 225 mm.; 11⅝ × 8⅞″.

70. YVETTE GUILBERT — "LINGER LONGER, LOO." Lithograph in black, 1898 (W. 263 ii/iii; D. 259; A. 315). 296 × 234 mm.; 11⅝ × 9¼″.

Yvette Guilbert's description of her facial makeup in her autobiography corroborates Lautrec's portrait. She wrote, "My mouth was by nature wide and thin, and I refused to make it small with makeup, as at that time all the actresses were drawing theirs into a Cupid's bow.... My mouth, dazzling, lacquered, red with the red of a geranium in the sun, was like a slash across my pale face, waxen white as a mask of death." ("Linger Longer, Loo" was a popular song of the period.)

71–73. From: PORTRAITS D'ACTEURS ET D'ACTRICES — TREIZE LITHOGRAPHIES PAR HENRI DE TOULOUSE-LAUTREC. Thirteen lithographs printed in black, 1898 (W. 266–278; D. 150–162; A. 166–178).

Treize Lithographies, a portfolio of 13 portraits of theatrical personalities, was commissioned to commemorate the 1895 Paris season. The original London publisher wanted a series of 30 portraits, but this larger project never materialized.

71. SARAH BERNHARDT, DANS "CLÉOPÂTRE" (?). Lithograph printed in black on wove paper laminated to thick cardboard, 1898 (W. 266B; D. 150; A. 166). From the small edition published during Lautrec's life by Les XX. 285 × 238 mm.; 11¼ × 9⅜″.

When Loÿs Delteil began cataloguing Lautrec's prints some 25 years after this date, the identities of a number of the entertainers were in doubt. Subsequent cataloguers, disputing Delteil's designation of this actress as Sarah Bernhardt, have identified her as Loie Fuller. (Cléopâtre was an 1890 play by Victorien Sardou, who wrote many of Bernhardt's successes.)

72. JEANNE GRANIER. Lithograph printed in black on China paper, 1898 (W. 270D; D. 154; A. 178). From the

edition of 300 published in 1906 by Gustave Pellet. 288 × 233 mm.; 11⅞ × 9⅛″.

Photographic evidence confirms that this actress is indeed Jeanne Granier, an operetta star who turned to straight comedy in 1895. She played opposite Lucien Guitry in Maurice Donnay's *Amants* (*Lovers*) that year at Sarah Bernhardt's Théâtre de la Renaissance.

73. JEANNE HADING. Lithograph printed in black on China paper, 1898 (W. 274D; D. 158; A. 172). From the edition of 300 impressions published in 1906 by Gustave Pellet. 285 × 231 mm., 11¼ × 9⅛″.

This ninth lithograph in the series of portraits of actors and actresses is probably *not* Jeanne Hading, its long-accepted title. Mme *Jane* Hading, an actress portrayed by Lautrec in two unpublished lithographic portraits (W. 280 & 281; D. 262 & 263), had strikingly different facial characteristics from the woman depicted here. While photographic confirmation is not available, this is probably Mlle Jeanne *Harding*, who in fact—according to the October 25, 1895, issue of *Le Figaro*—joined Polin and Yvette Guilbert, two other performers featured in *Treize Lithographies,* for a benefit appearance at La Bodinière.

74. MLLE MARCELLE LENDER EN BUSTE, DE TROIS QUARTS. Lithograph printed in sanguine on gray-blue wove paper, 1898 (W. 279; D. 261; A. 302). Signed in pencil by the artist, numbered typographically from the edition of 45 and embossed with the blindstamp of the publisher, Goupil. 250 × 227 mm.; 9⅞ × 8⅞″.

In this delicate rendering of Mlle Lender, Lautrec composed his final lithographic tribute to the celebrated actress. In addition to his fascination with her other charms, Lautrec loved the sight of her handsome, finely chiseled nostrils, the features most prominently noticeable from his lower vantage point.

75. COUVERTURE POUR "L'EXEMPLE DE NINON DE LENCLOS AMOUREUSE." Lithograph printed in black on wove paper for use as a book cover, 1897 (W. 298 ii/ii; D. 230; A. 273). An unfolded proof apart from the edition of 500 numbered copies. 200 × 251 mm.; 7⅞ × 9⅞″.

Jean de Tinan, the author of the novel for which this lithograph served as pictorial wrappers, was a somewhat minor participant in the Symbolist movement. Ninon was a famous seventeenth-century lady of fashion.

76. AU HANNETON. Lithograph printed in dark-brown ink on wove paper, 1898 (W. 310; D. 272; A. 290). Signed in pencil by the artist, stamped with his red monogram, numbered typographically from the edition of 100 impressions and embossed with the blindstamp of the publisher, Goupil. 355 × 255 mm.; 14 × 10″.

Le Hanneton (The June Bug) was a brasserie in the rue Pigalle frequented by lesbians, and Lautrec there found a subject for what the critic Claude Roger-Marx considered one of the masterpieces of lithography. Lautrec's work, he wrote, is "as terse as a Whistler, and exquisite in its ashen sadness. Ash-grey, too, are the eyes of the customer with her hard mouth and knotty finger-joints. Everything here belongs to the past: even the tankard and carafe look old. By what miracle does the artist maintain this fantastic ambiance composed of silvery dust, in which the only dark spot is formed by the quivering tail of the little animal sitting faithfully beside its mistress?"

77. PROMENOIR. Lithograph printed in black on Japan paper, 1898 (W. 315; D. 290; A. 324). Signed with the artist's red monogram stamp, numbered from the edition

of 100 impressions and embossed with the blindstamp of the publisher, La Maison Moderne of J. Meier-Graefe ("MML"). Published in *Germinal, Album de XX estampes originales.*

The two men promenading were intimates of Lautrec. The tall one is Dr. Gabriel Tapié de Céleyran, his double first cousin (the "doctor's" mother was Lautrec's father's sister and his father was Lautrec's mother's brother), who became his inseparable companion—and the butt of many jokes—in his travels and sojourns in the Paris demi-monde. Lautrec was amused by the look of himself and the "doctor" together—a Mutt and Jeff couple—and placed the pair in a number of paintings. The other man in the print is the weasel-faced photographer Paul Sescau, who, Edouard Julien records, "for his own part liked to entice young women" whom Lautrec brought to his studio as models. Lautrec made a poster for his friend Sescau (No. 18) that emphasized the photographer's lecherous approach to his craft. The two women are regulars of La Souris, a restaurant with a reputation as a haunt of lesbians.

78 & 79. From: HISTOIRES NATURELLES. Book with 23 lithographs printed in black on wove paper, 1899 (W. 326–348; D. 297–319; A. 333–355; The Artist & the Book 304; Rauch 17). With text by Jules Renard. From the edition of 100 copies, published by H. Floury, Paris. Page size 312 × 255 mm.; 12¼ × 8¾″.

The *Histoires Naturelles* contains some of Lautrec's most refined draftsmanship and, with *Yvette Guilbert* (Nos. 67–70), is considered one of the masterpieces of the illustrated book. It was Lautrec who requested the pleasure of illustrating Renard's bestiary, and Renard agreed, hoping for descriptions that "would please the animals themselves." The two creative personalities clashed. Lautrec resented the book's limitation to mundane animals, while Renard, although paid homage by a cover design of a fox, objected to a number of Lautrec's drawings. Lautrec began sketching the animals in 1896 and finished most of them—some from memory and some following visits to the Jardin d'Acclimatation and the Jardin des Plantes—in 1898. Today we are amazed that it took Floury 20 years to sell out the edition of 100 copies.

78. L'EPERVIER. Lithograph printed in black with lettering on wove paper, 1899 (W. 334; D. 305; A. 341). As published in *Histoires Naturelles*, Floury 1899. 222 × 213 mm.; 8¾ × 8⅜″.

79. L'ARAIGNÉE. Lithograph printed in black with lettering on wove paper, 1899 (W. 337; D. 308; A. 344). As published in *Histoires Naturelles*, Floury 1899. 200 × 160 mm.; 7⅞ × 6¼″.

80 (FRONTISPIECE). LE JOCKEY — CHEVAUX DE COURSES. Lithograph printed in black on China paper, 1899 (W. 356 i/ii; D. 279; A. 365). From the edition of 100 impressions of the first state before the addition of color stones. 516 × 362 mm.; 20¼ × 14¼″.

Horses were of artistic significance to Lautrec ever since his boyhood on the family estates in the south of France. Some of his first paintings and drawings were of horses and horse-drawn carriages. In 1899 the publisher Pierrefort commissioned him to execute a series of racing subjects. Lautrec's alcoholism permitted the completion of only four of these racetrack prints, of which this one is the major work.

Color plate H. JANE AVRIL. Lithograph printed in colors on wove paper with lettering for use as a poster, 1899 (W. 360 iii/iii; D. 367; A. 323). 560 × 344 mm.; 22 × 13½″.

1. Moulin-Rouge (La Goulue). Poster, 1891.

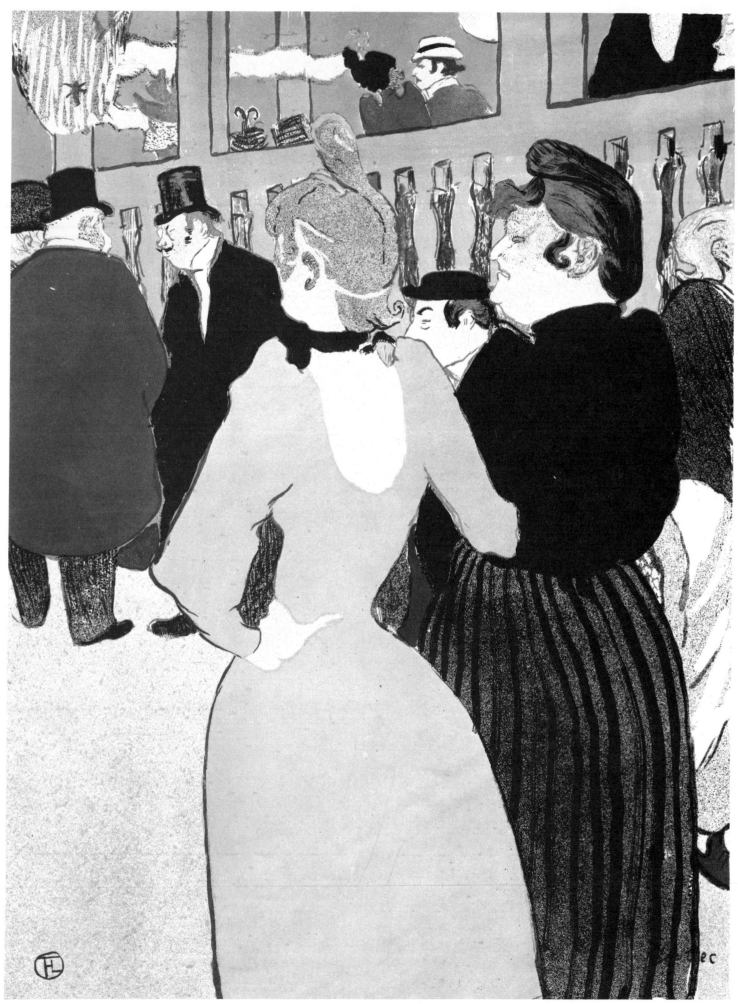

2. At the Moulin-Rouge — La Goulue and the Môme Fromage. 1892.

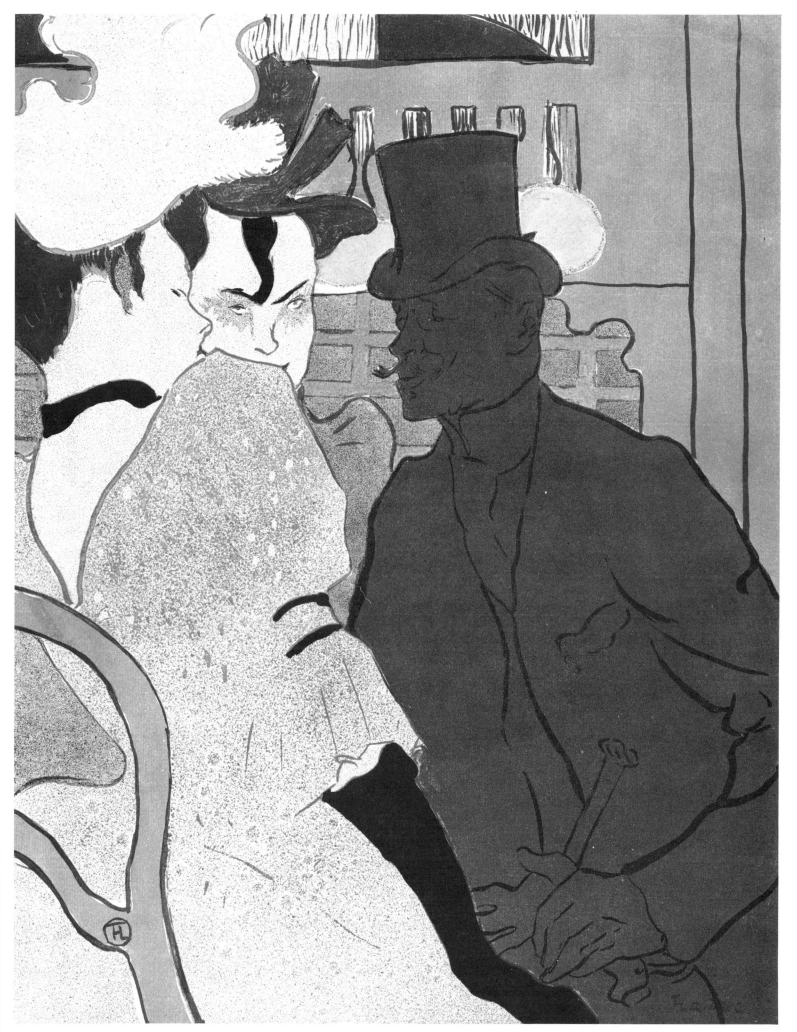

3. The Englishman at the Moulin-Rouge. 1892.

4. The Ambassadeurs: Aristide Bruant. Poster, 1892.

5. Miss Loie Fuller. 1892.

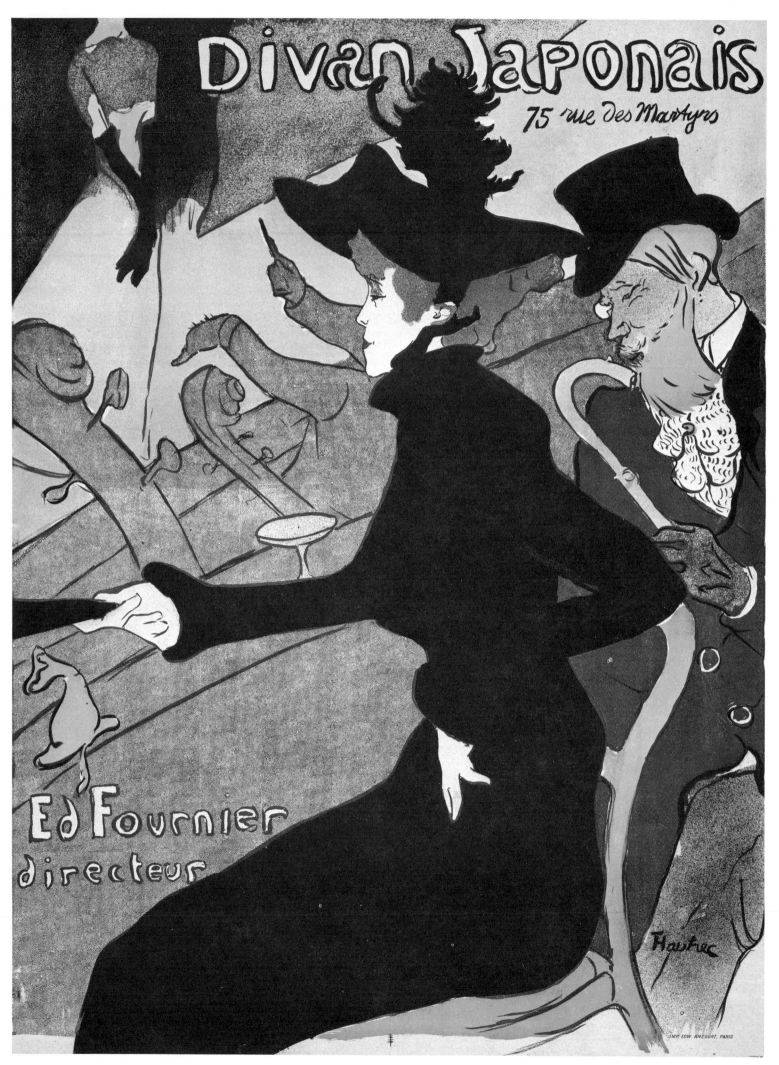

6. The Divan Japonais. Poster, 1893.

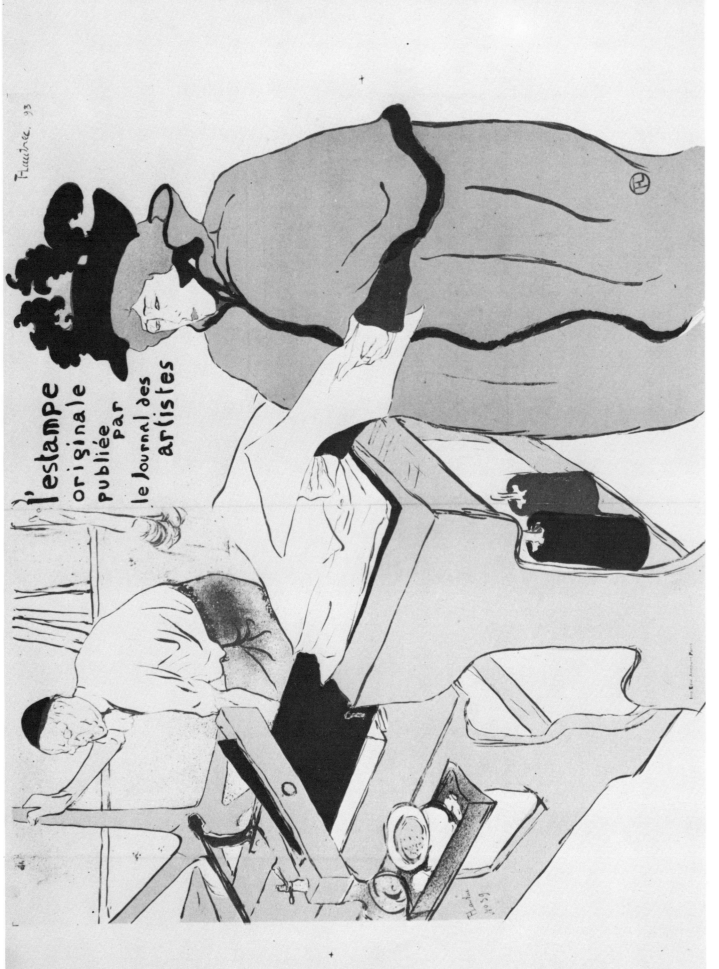

7. Cover for *L'Estampe originale*. 1893.

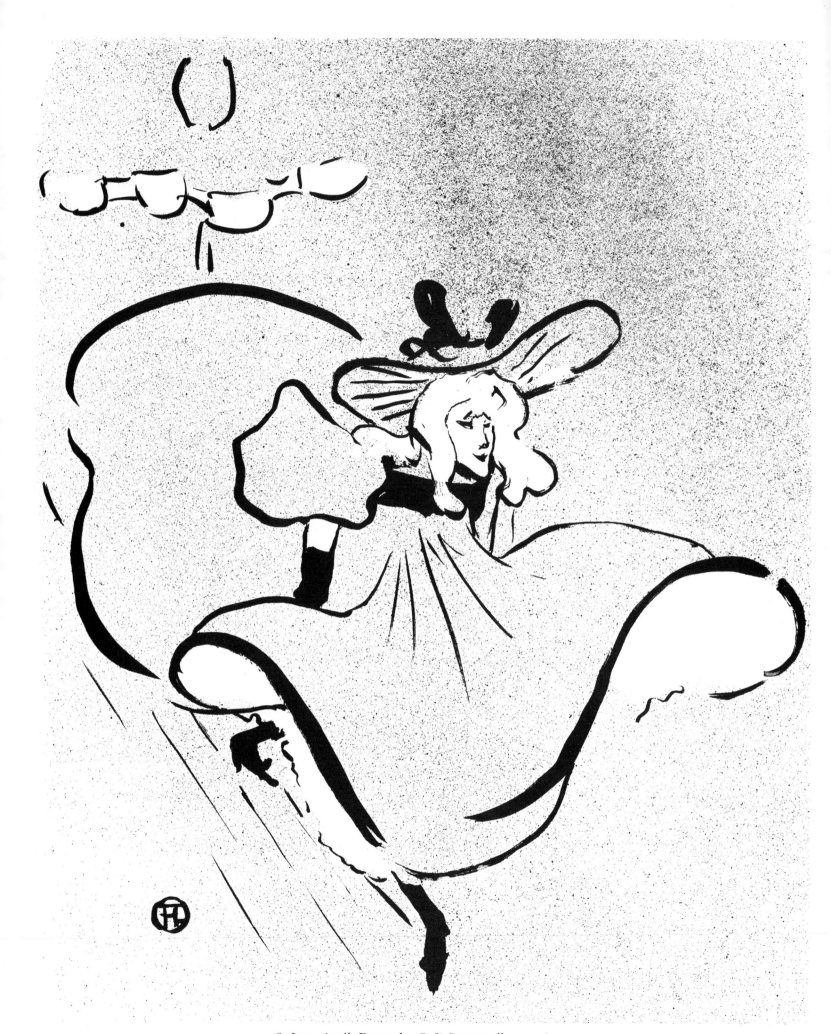

8. Jane Avril. From the *Café-Concert* album, 1893.

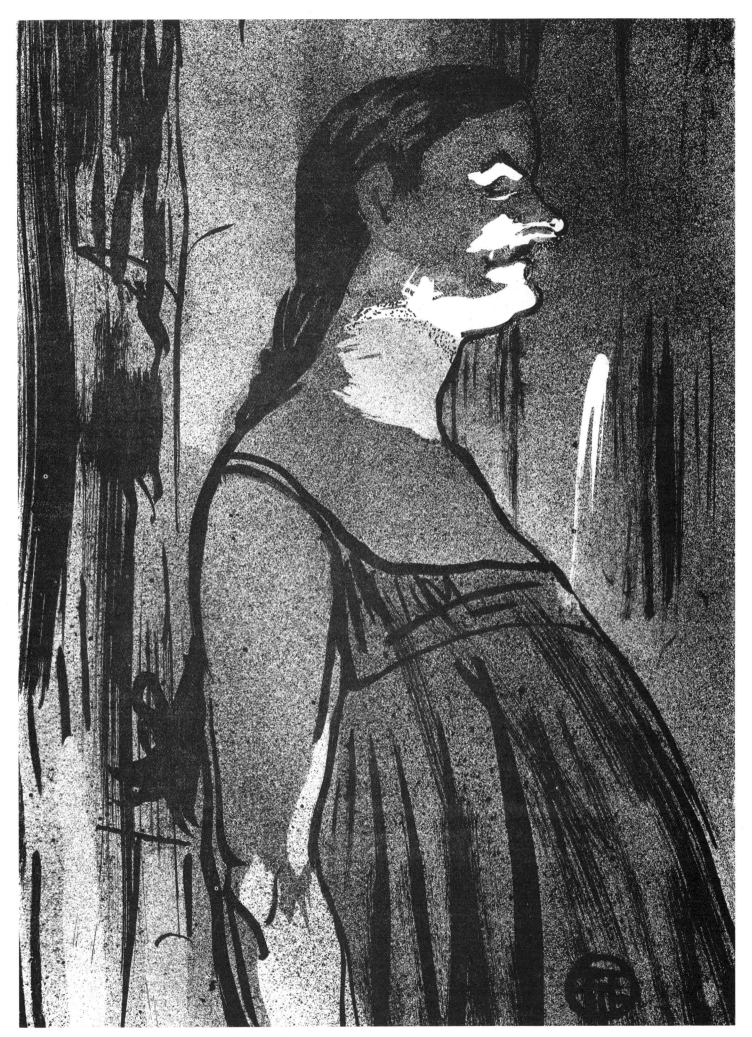

9. Mme Abdala. From the *Café-Concert* album, 1893.

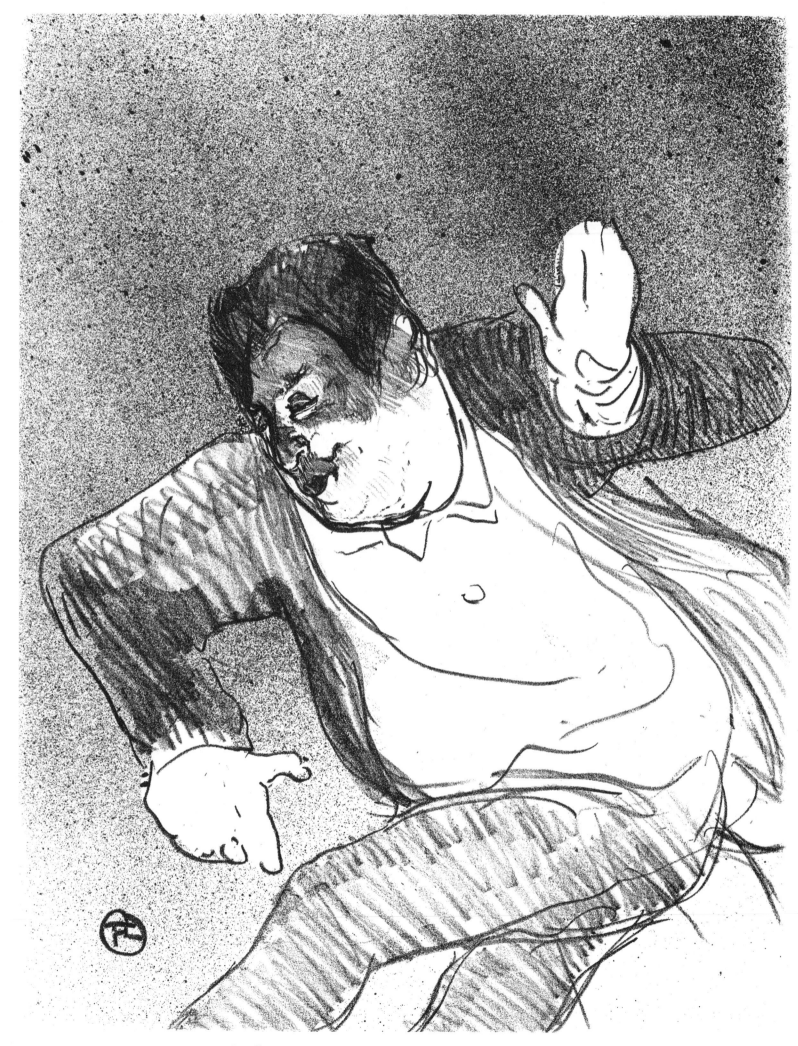

10. Caudieux — Petit Casino. From the *Café-Concert* album, 1893.

11. Wrapper of the song-sheet portfolio *The Old Stories*. 1893.

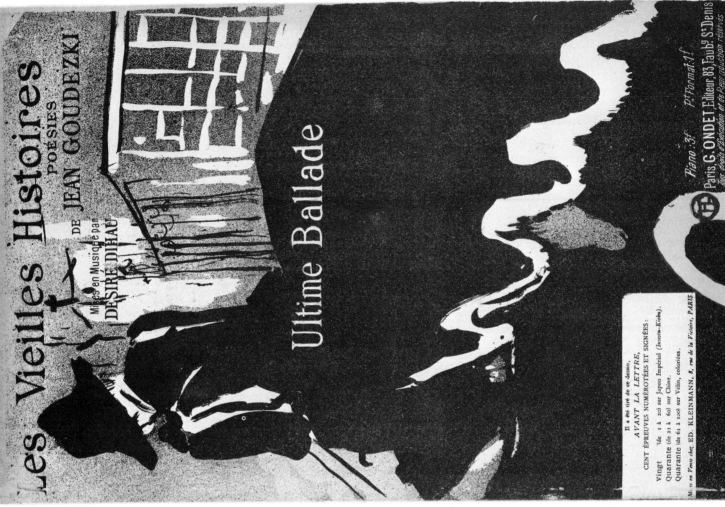

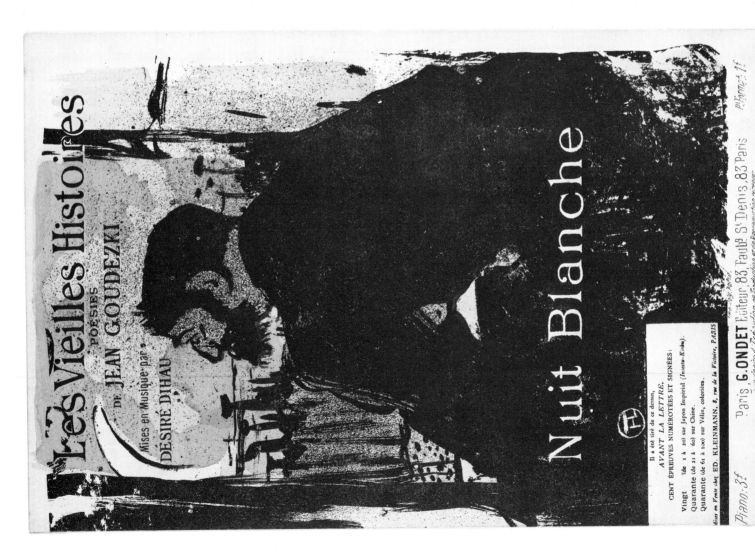

12. Two song-sheet covers from the *Old Stories* portfolio, 1893. LEFT: Sleepless Night. RIGHT: Last Ballad.

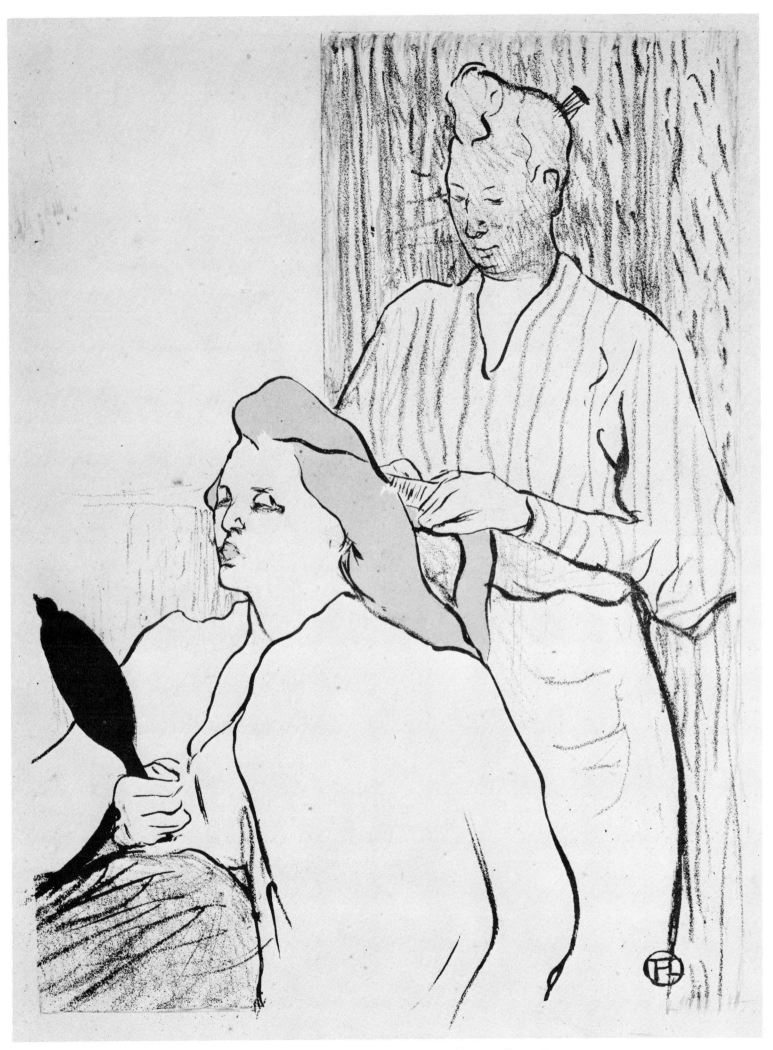

13. The Hairdresser — Program for the Théâtre Libre. 1893.

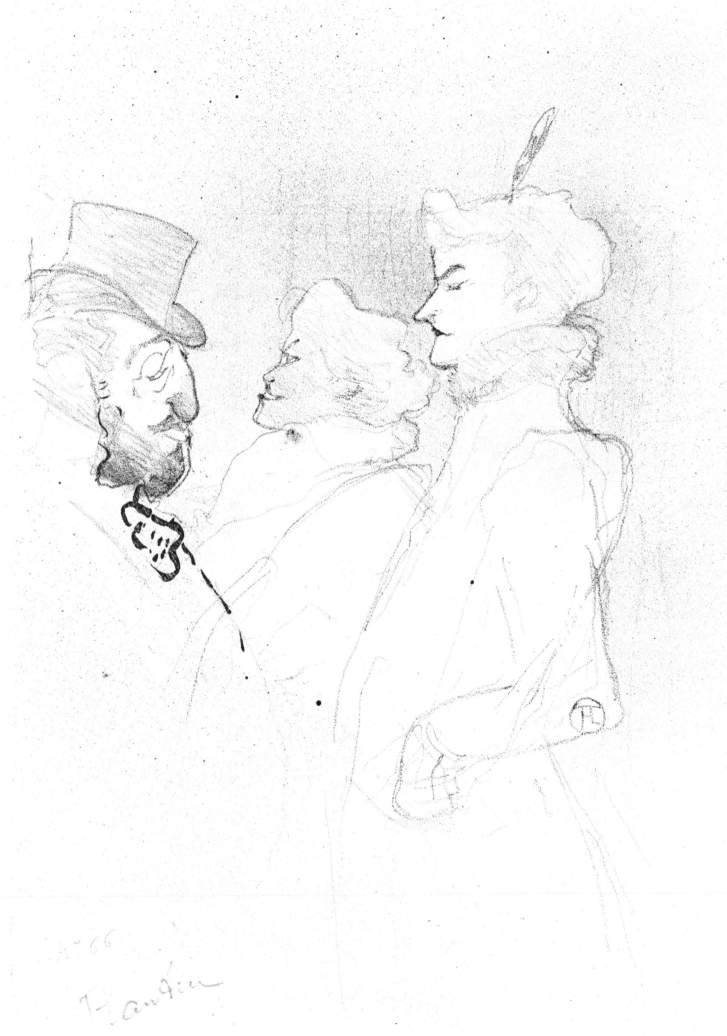

14. "Why not? . . . Just one time doesn't matter." 1893.

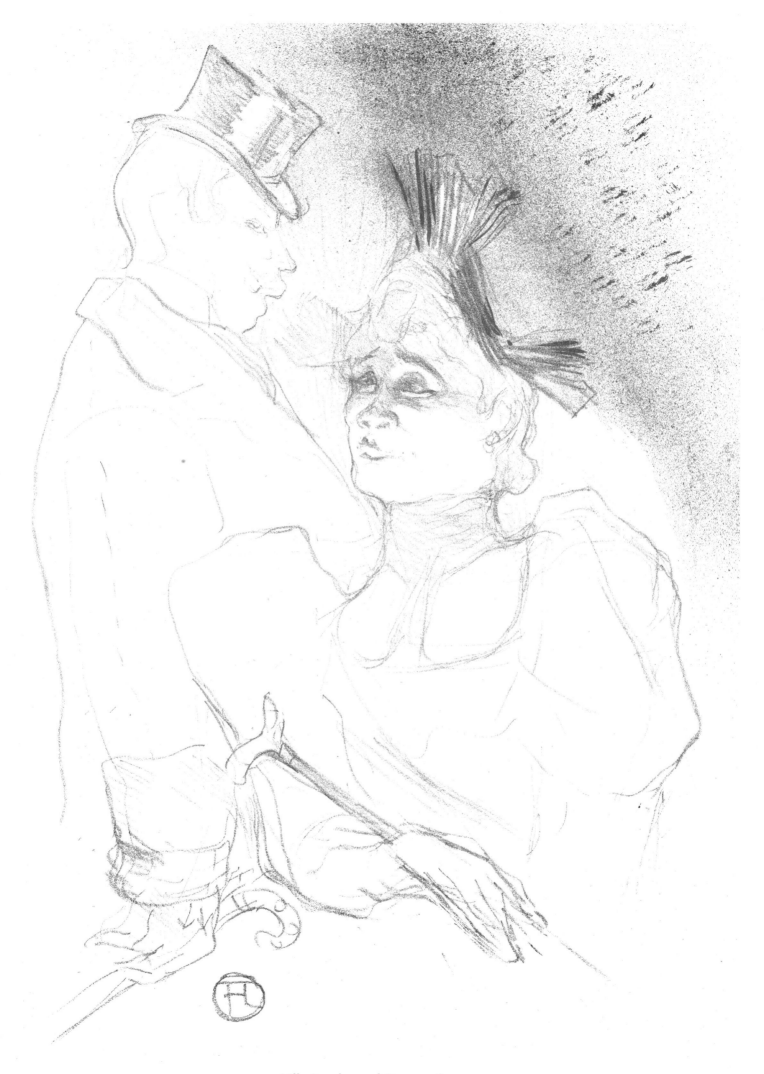

15. Mlle Lender and Baron. 1893.

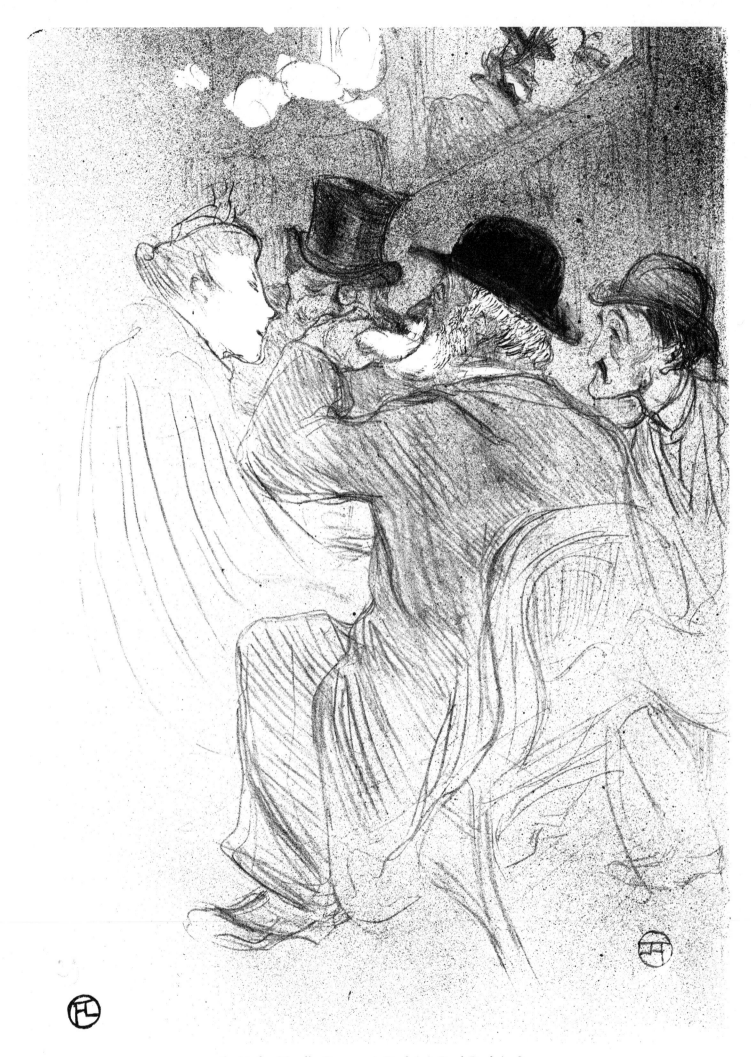

16. At the Moulin-Rouge: A Rude! A Real Rude! 1893.

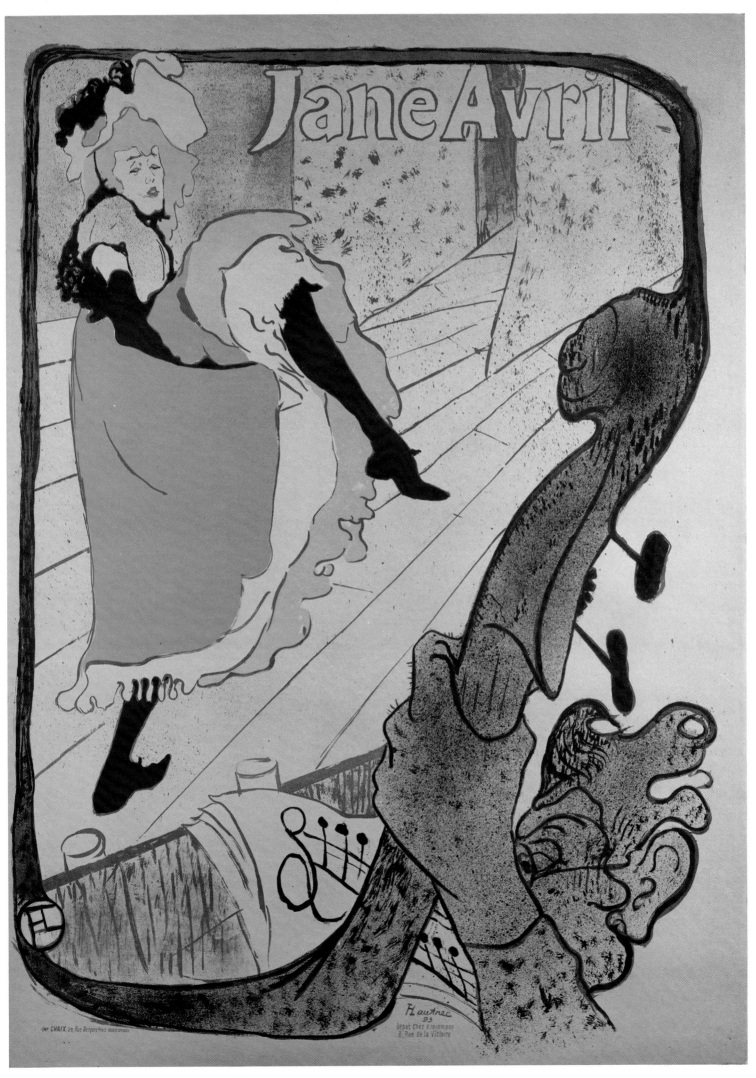

A. Jane Avril. Poster, 1893. (See text in List of Plates following no. 7.)

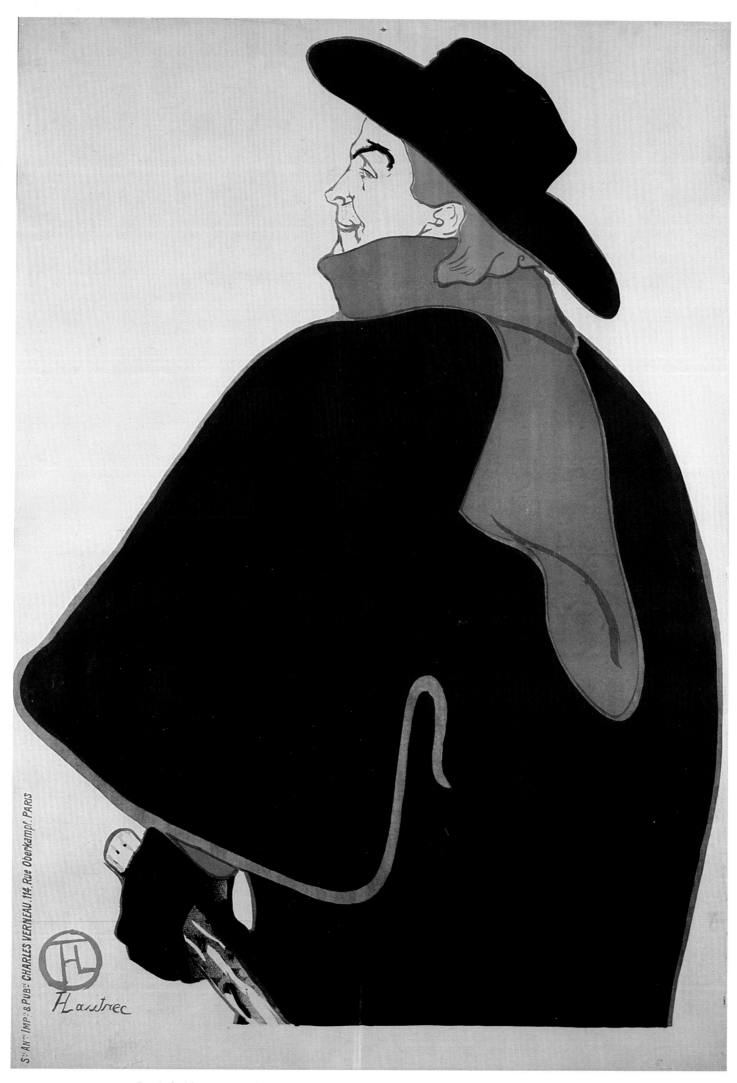

B. Aristide Bruant in His Cabaret. Poster, 1893. (See text in List of Plates following no. 7.)

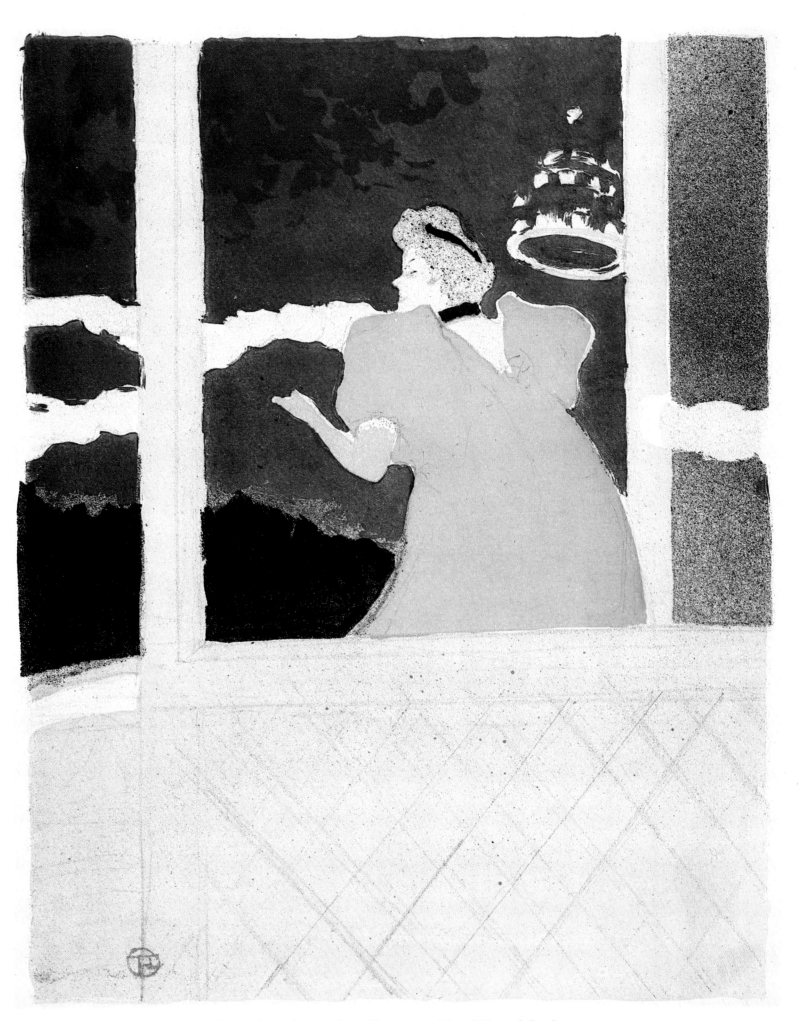

C. At the Ambassadeurs. 1894. (See text in List of Plates following no. 23.)

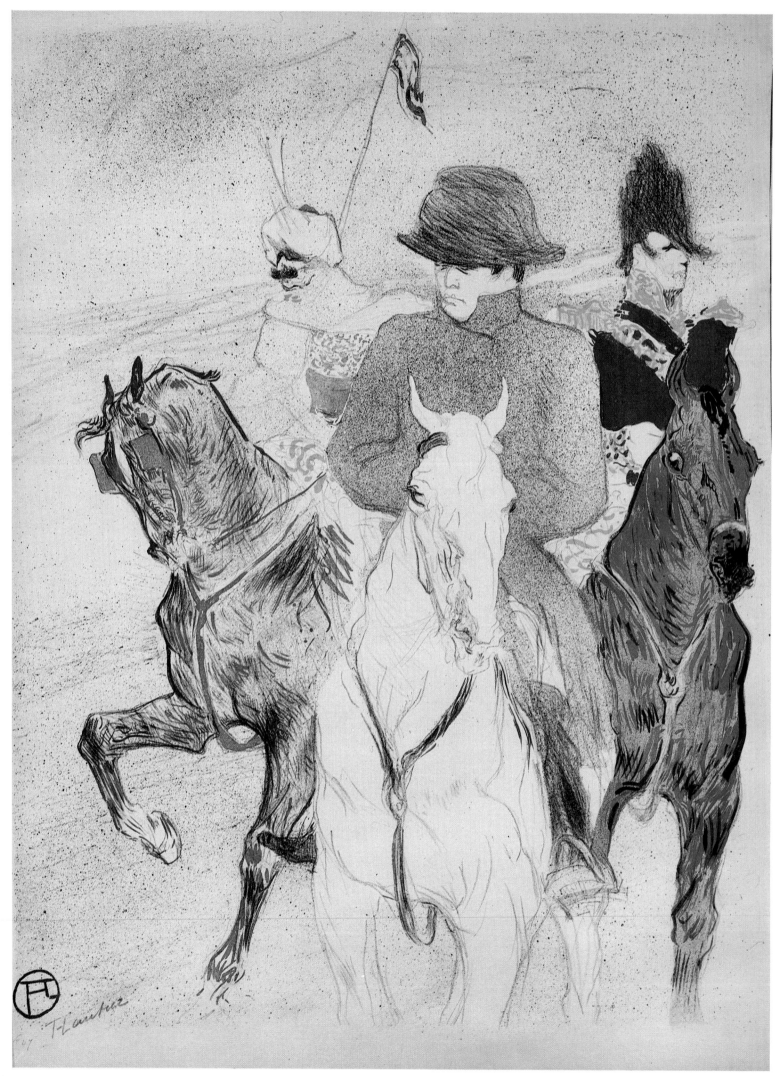

D. Napoleon. 1895. (See text in List of Plates following no. 44.)

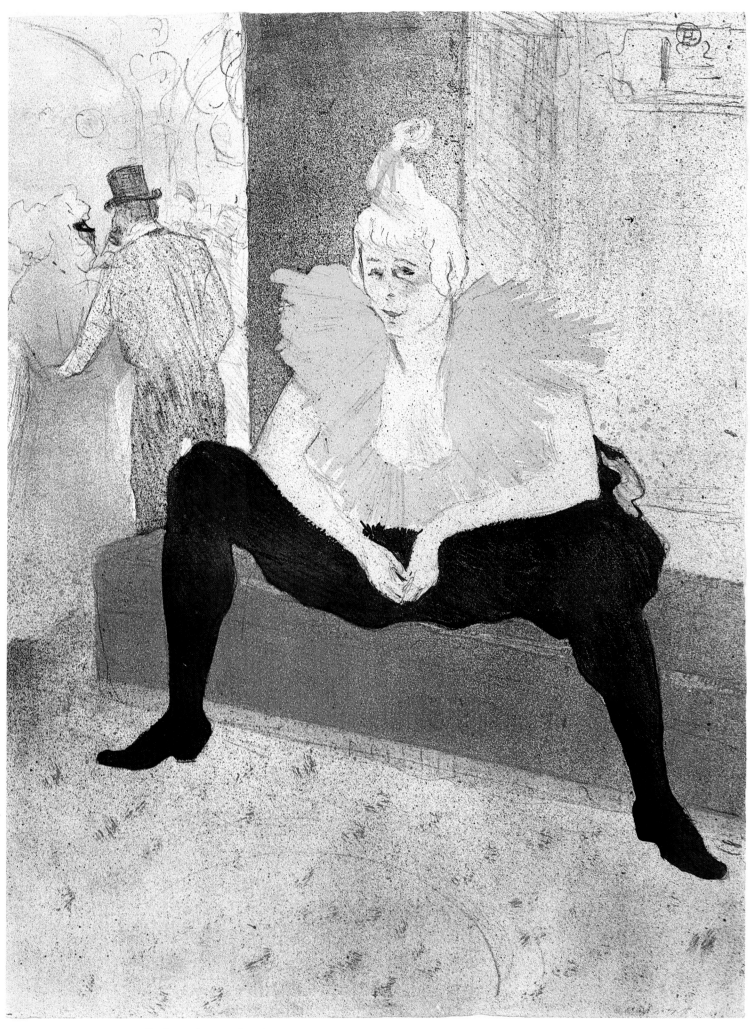

E. Seated Female Clown — Mlle Cha-U-Ka-O. 1896. (See text in List of Plates
following no. 54.)

F. A Prince's Idyll. 1897. (See text in List of Plates following no. 62.)

G. Outing in the Country. 1897. (See text in List of Plates following no. 64.)

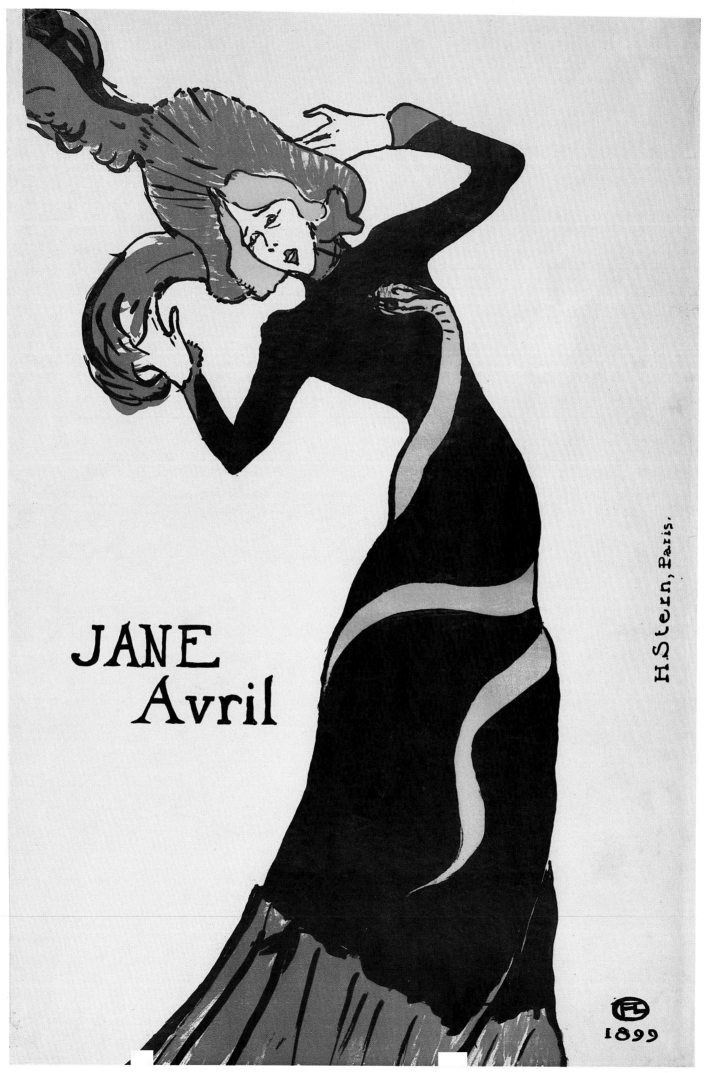

H. Jane Avril. Poster, 1899. (See text in List of Plates following no. 80.)

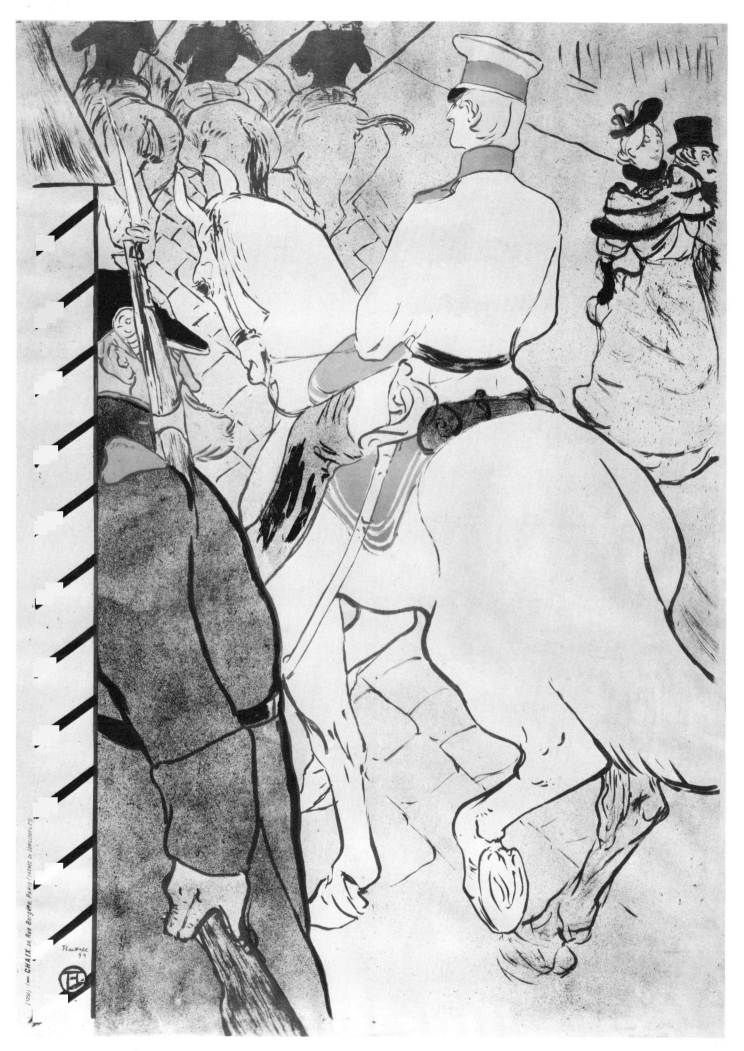

17. Babylon in Germany. Poster, 1894.

18. The Photographer Sescau. Poster, 1894.

19. Lugné-Poë in *Beyond Our Powers*. 1894.

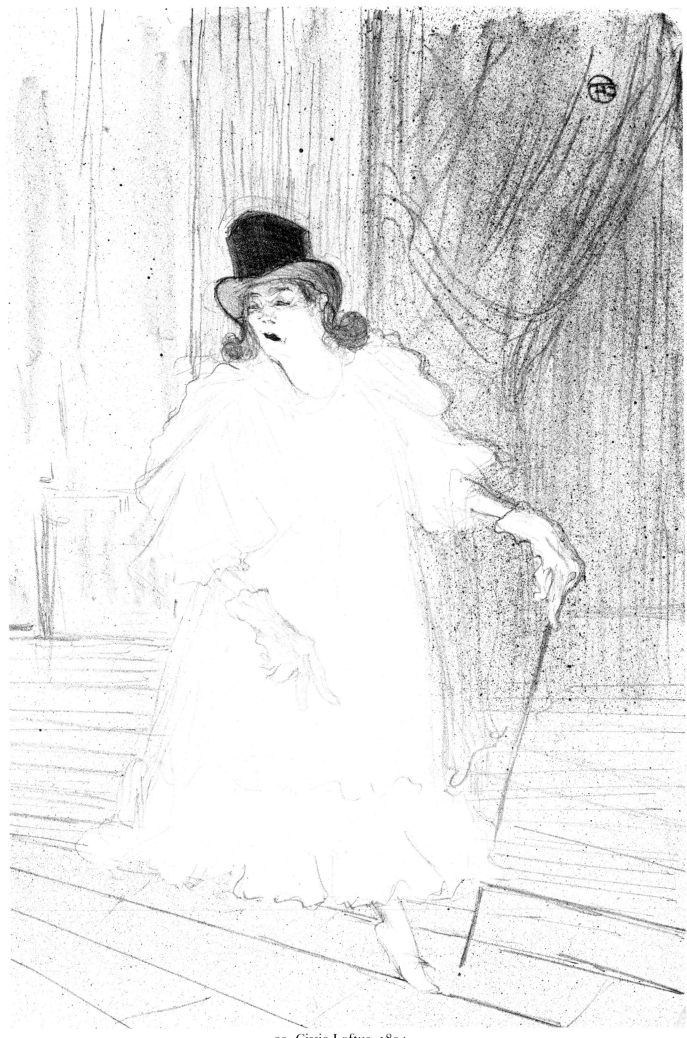

20. Cissie Loftus. 1894.

21. Miss Ida Heath — English Dancer. 1894.

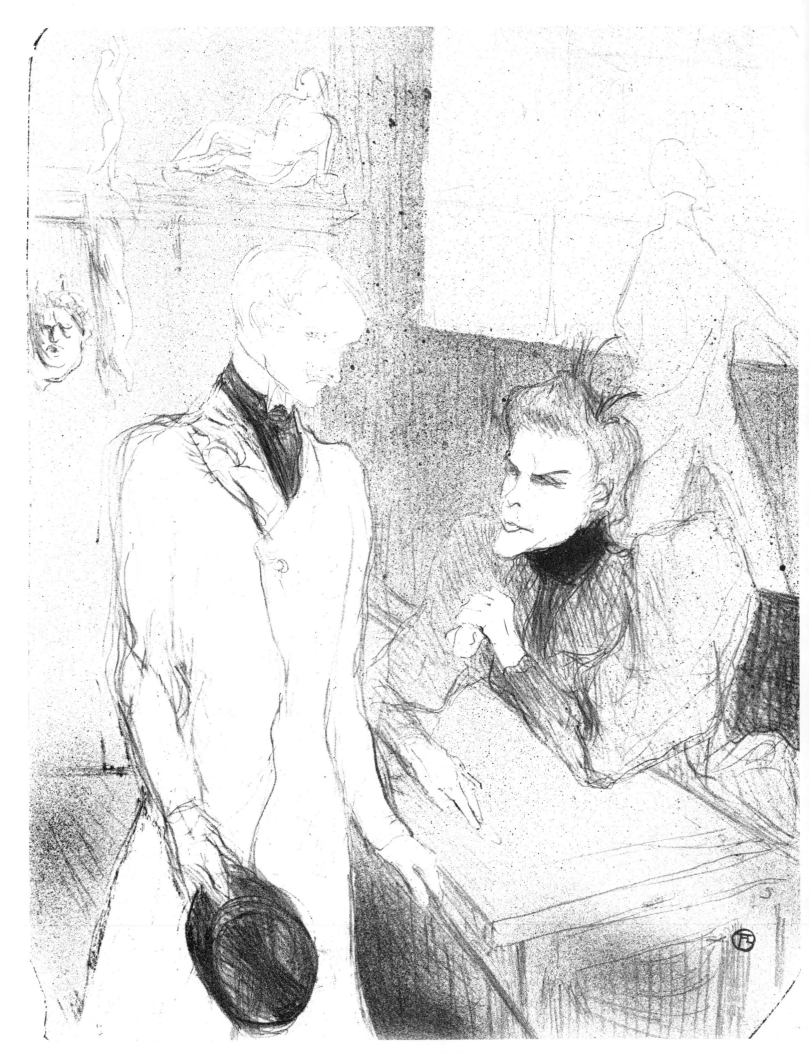

22. Brandès and Le Bargy in *Charlatans*. 1894.

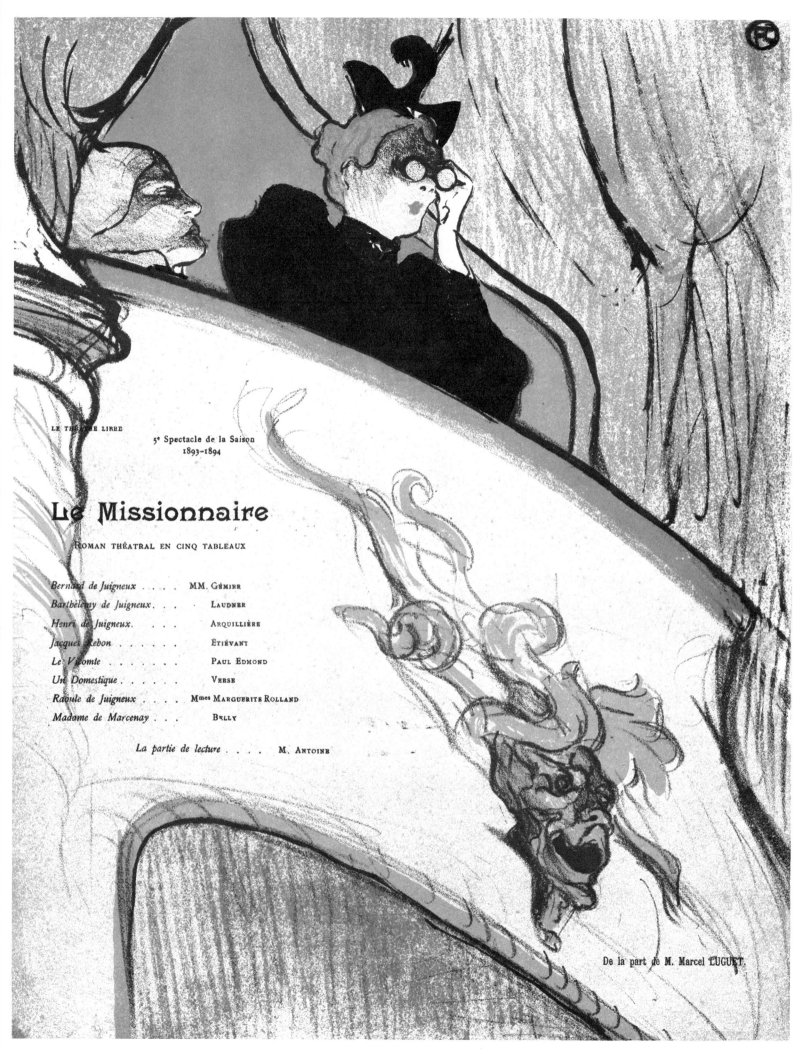

LE THÉÂTRE LIBRE

5e Spectacle de la Saison
1893-1894

Le Missionnaire

ROMAN THÉÂTRAL EN CINQ TABLEAUX

Bernard de Juigneux MM. GÉMIER
Barthélemy de Juigneux . . . LAUDNER
Henri de Juigneux. . . . ARQUILLIÈRE
Jacques Rebon ÉTIÉVANT
Le Vicomte PAUL EDMOND
Un Domestique VERSE
Raoule de Juigneux Mmes MARGUERITE ROLLAND
Madame de Marcenay . . . BULLY

La partie de lecture M. ANTOINE

De la part de M. Marcel LUGUET.

23. The Box with the Gilded Mask — Program for *The Missionary*. 1894.

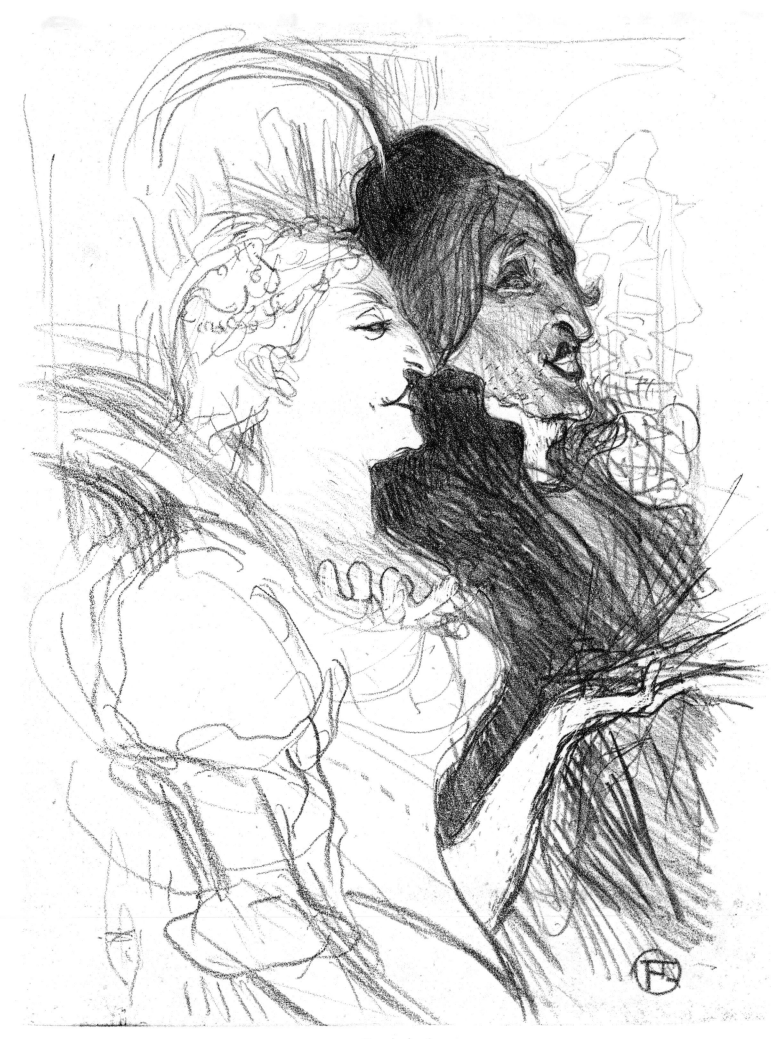

24. Carnival. 1894.

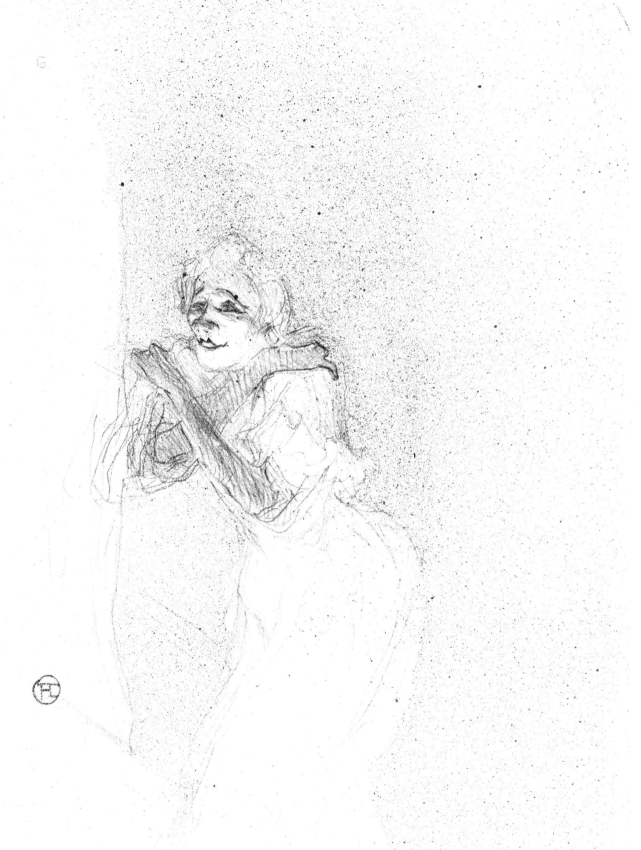

25. First *Yvette Guilbert* album, 1894, 5th plate.

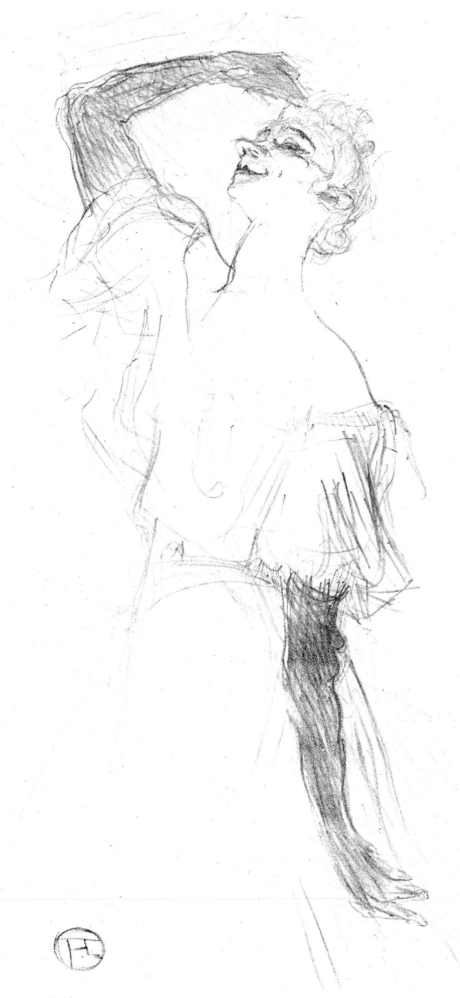

26. First *Yvette Guilbert* album, 1894, 7th plate.

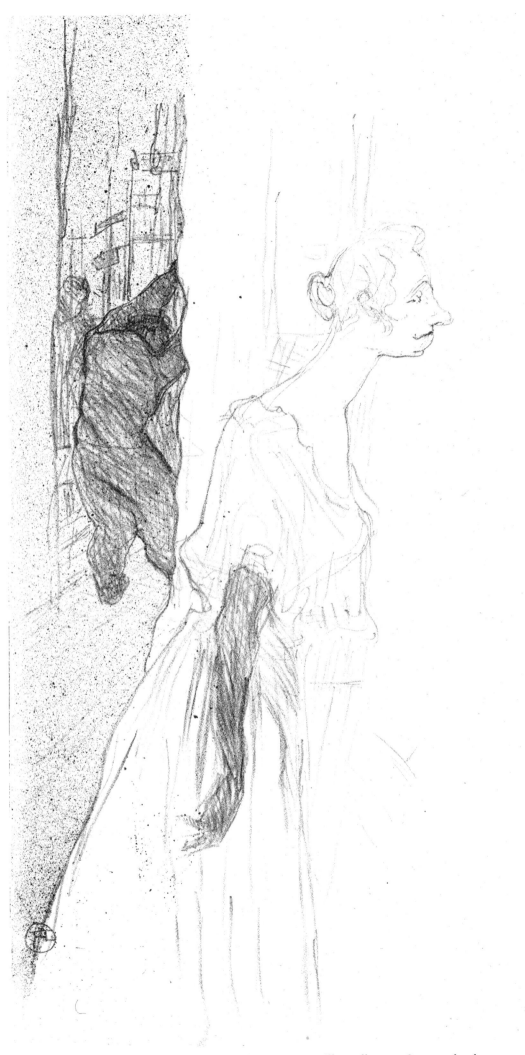

27. First *Yvette Guilbert* album, 1894, 11th plate.

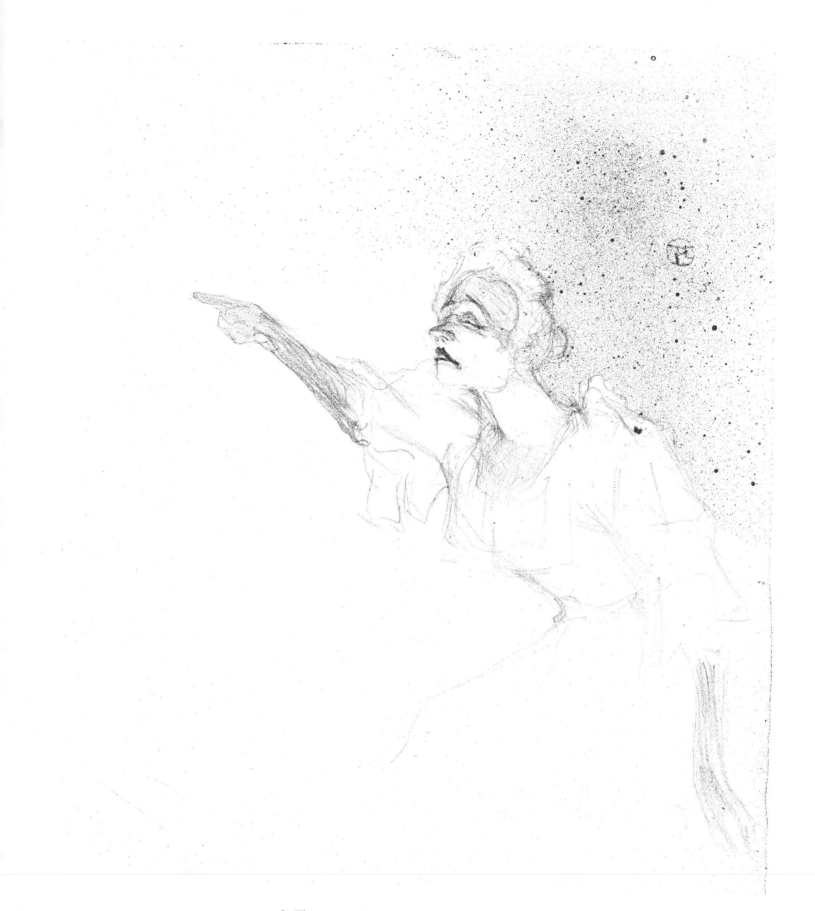

28. **First** *Yvette Guilbert* album, 1894, 12th plate.

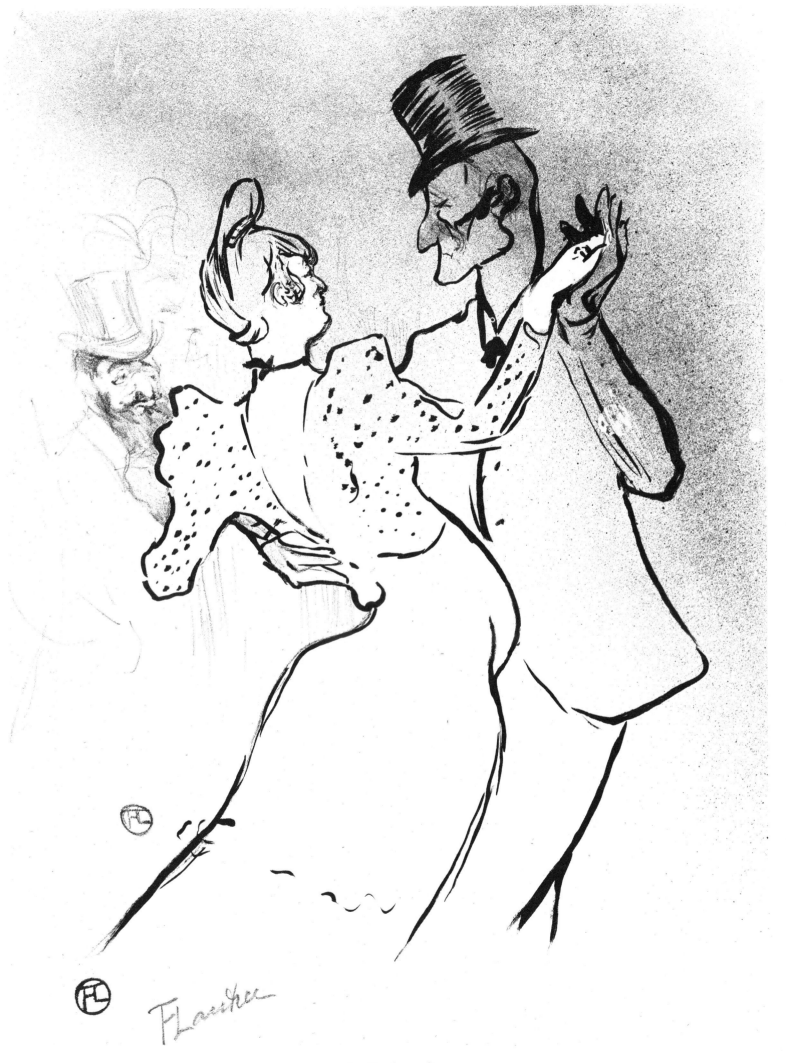

29. La Goulue. 1894.

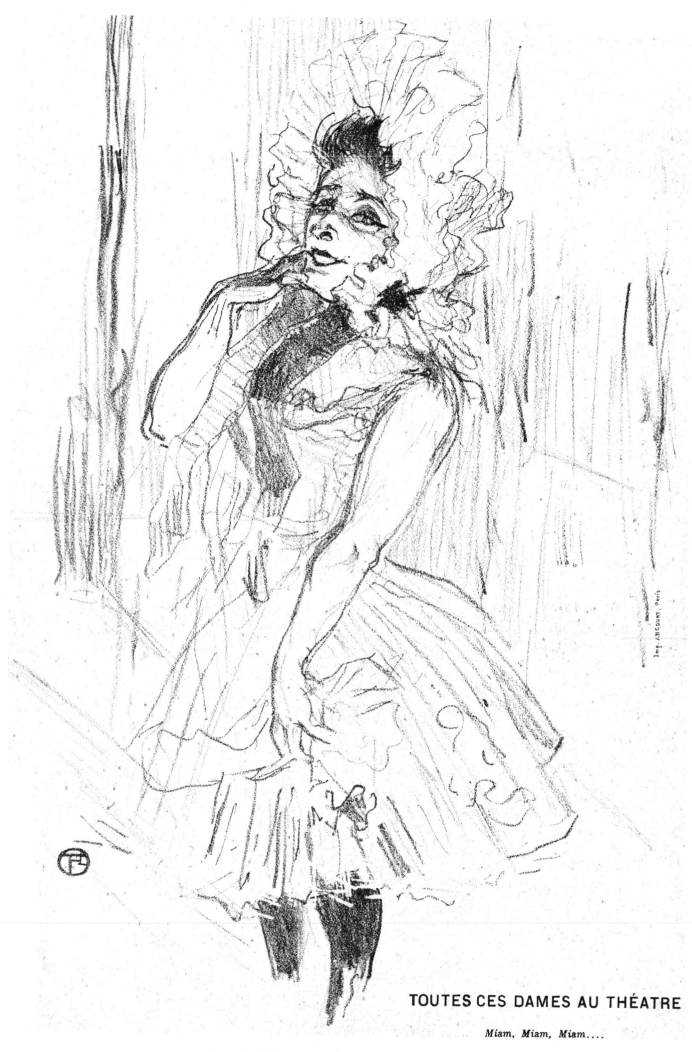

TOUTES CES DAMES AU THÉATRE

Miam, Miam, Miam....

30. Anna Held in *All These Ladies in the Theater.* 1894.

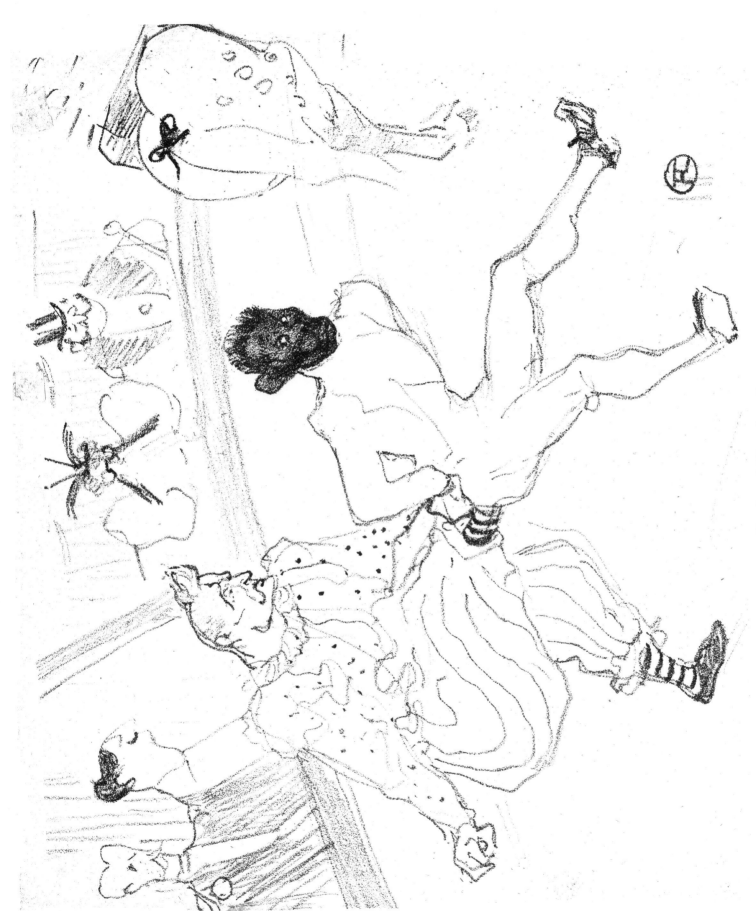

31. Footit and Chocolat. 1894.

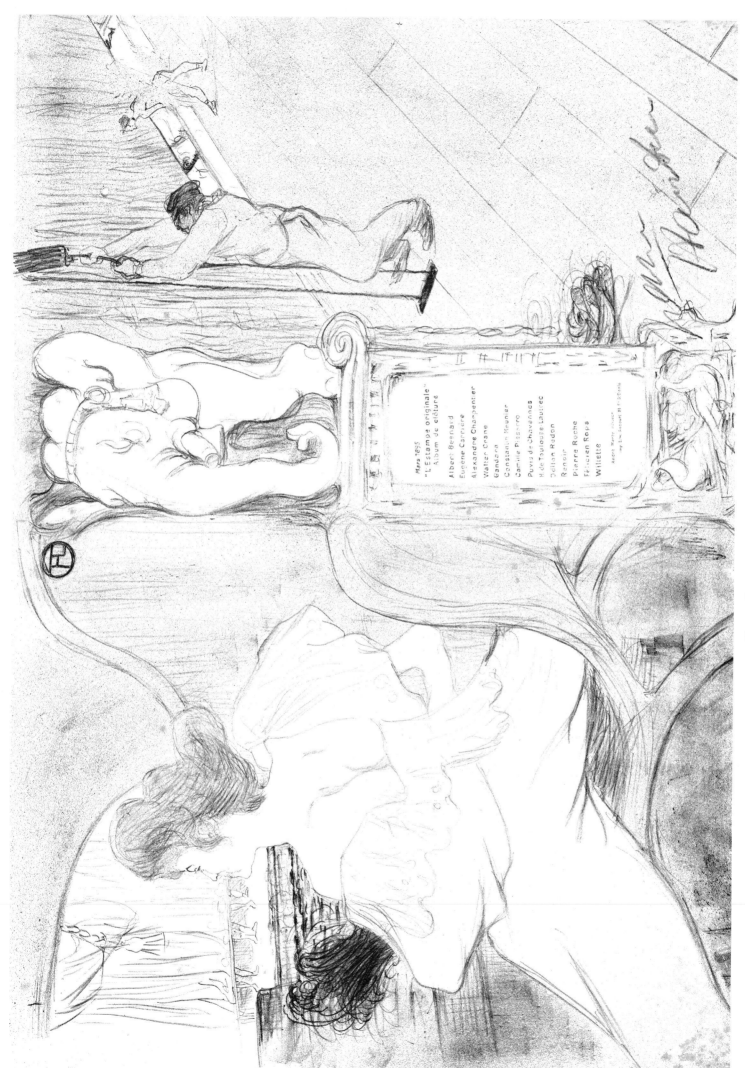

Mars 1895
"L'Estampe originale"
Album de clôture

Albert Besnard
Eugène Carrière
Alexandre Charpentier
Walter Crane
Gandara
Constantin Meunier
Camille Pissarro
Puvis de Chavannes
H. de Toulouse Lautrec
Odilon Redon
Renoir
Pierre Roche
Félicien Rops
Willette

André Marty, éditeur,
Imp. Edw. Ancourt 83 Fb St Denis

32. Cover for *L'Estampe originale*. 1895.

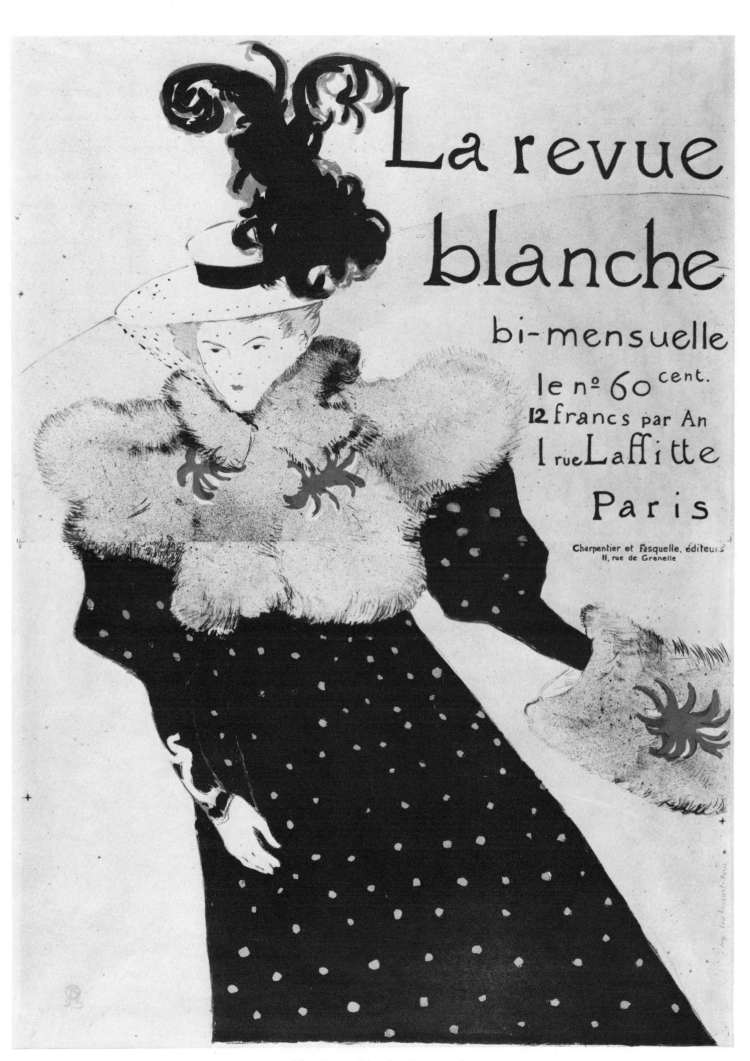

33. The *Revue Blanche*. Poster, 1895.

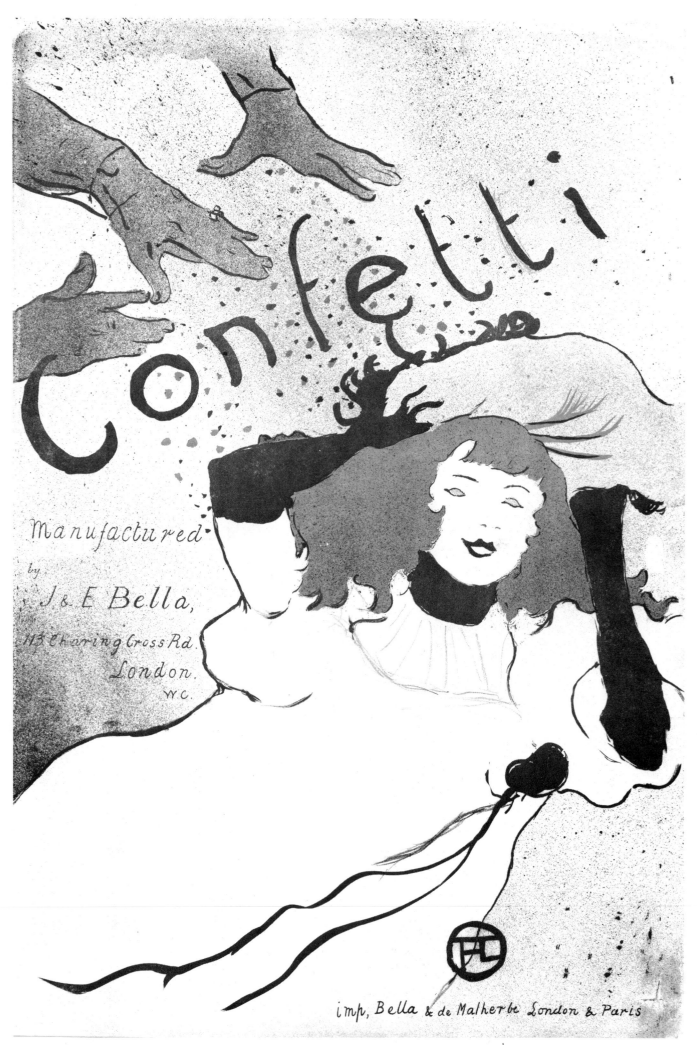

34. Confetti. Poster, 1895.

35. Back View of Lender Dancing the Bolero in *Chilpéric*. 1895.

36. Lender Dancing the Bolero in *Chilpéric*. 1895.

37. Front view of Lender in *Chilpéric*. 1895.

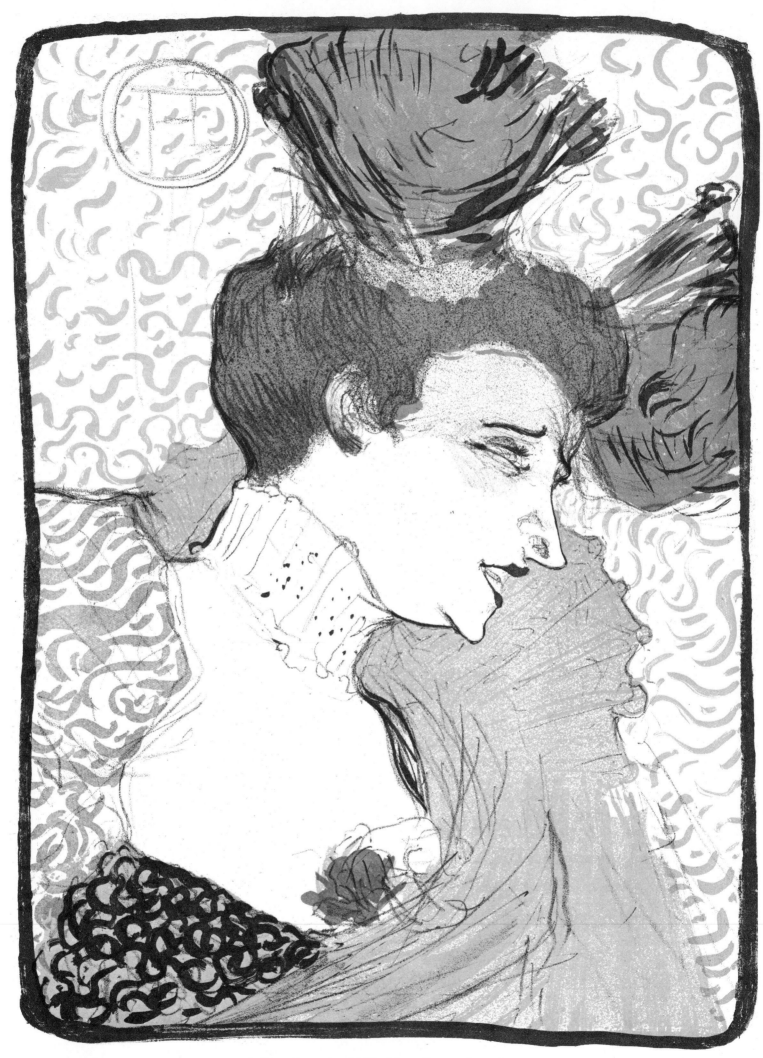

38. Bust Portrait of Mlle Marcelle Lender. 1895.

39. Mlle Marcelle Lender, Standing. 1895.

40. Lender and Auguez in *Fortunio's Song*. 1895.

41. Front view of Luce Myrès. 1895.

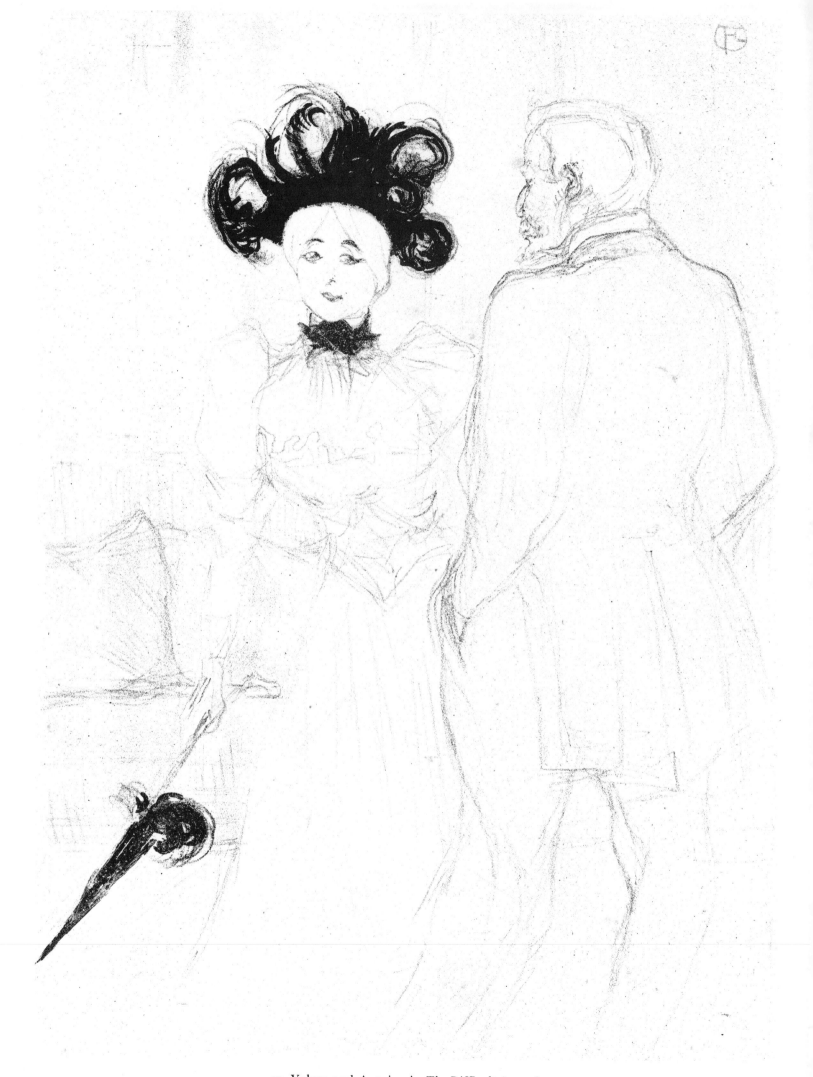

42. Yahne and Antoine in *The Difficult Age*. 1895.

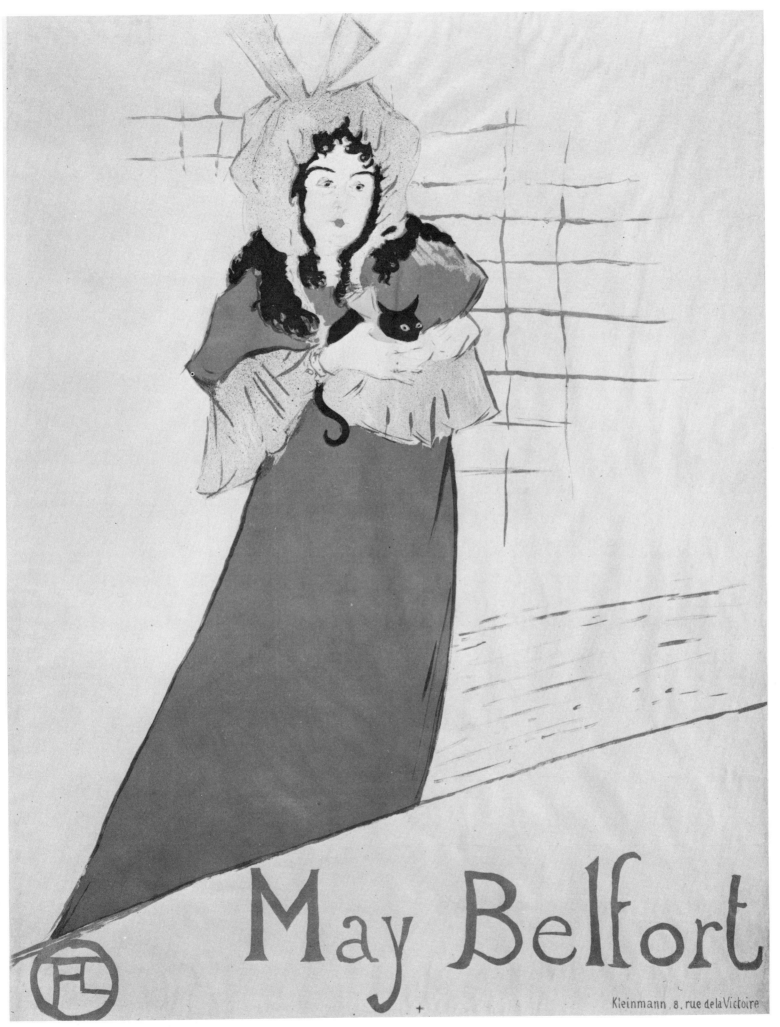

May Belfort

Kleinmann, 8, rue de la Victoire

43. May Belfort. Poster, 1895.

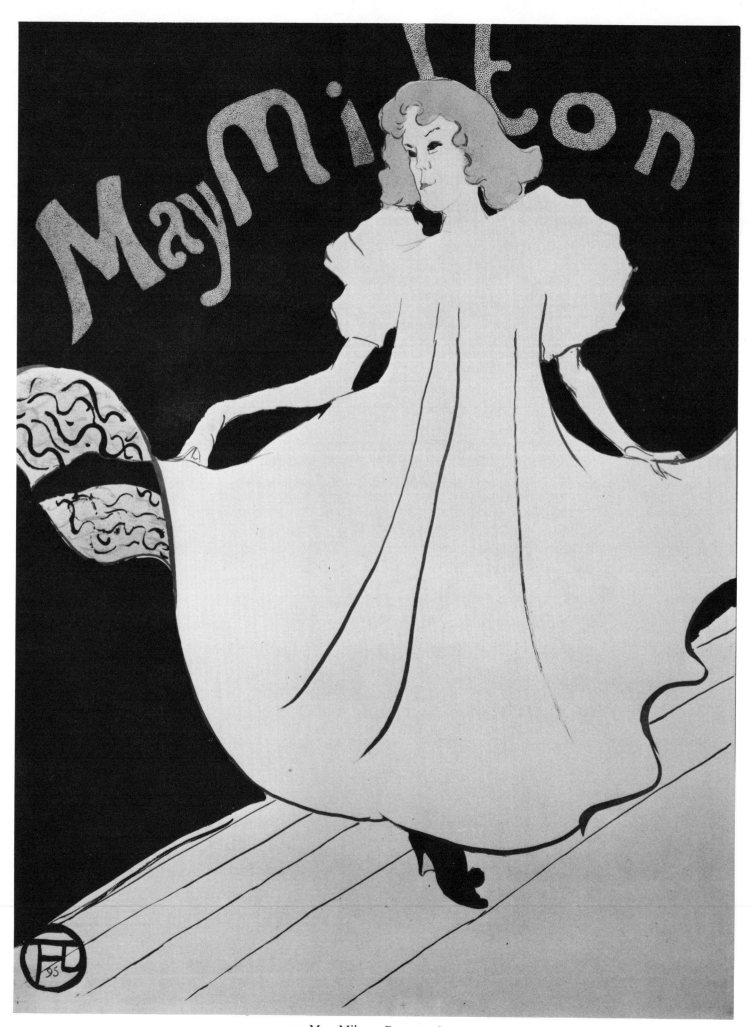

44. May Milton. Poster, 1895.

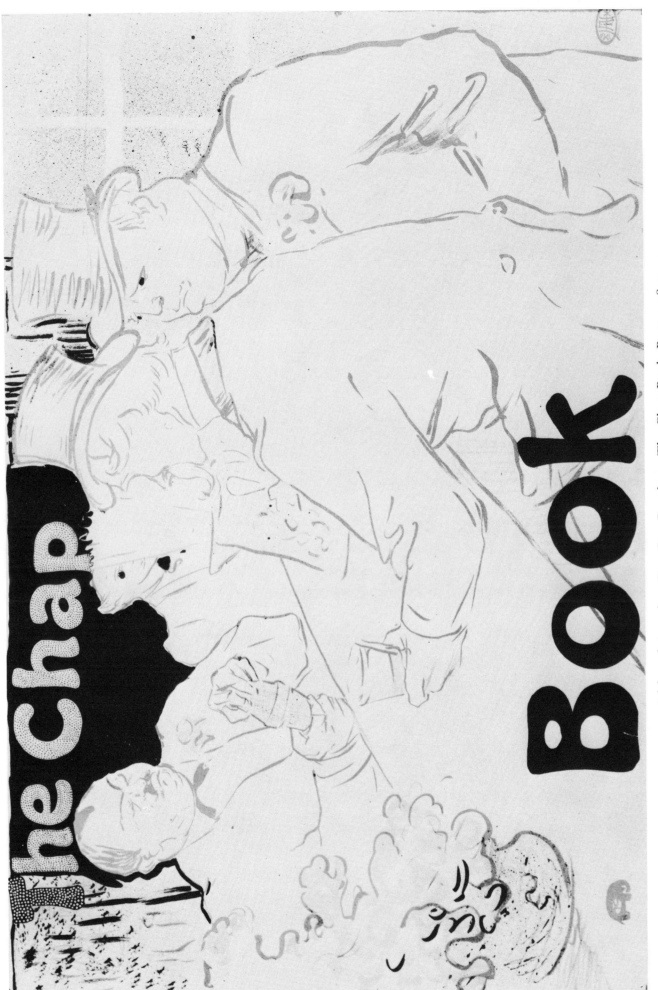

45. Irish and American Bar, Rue Royale — The Chap Book. Poster, 1895.

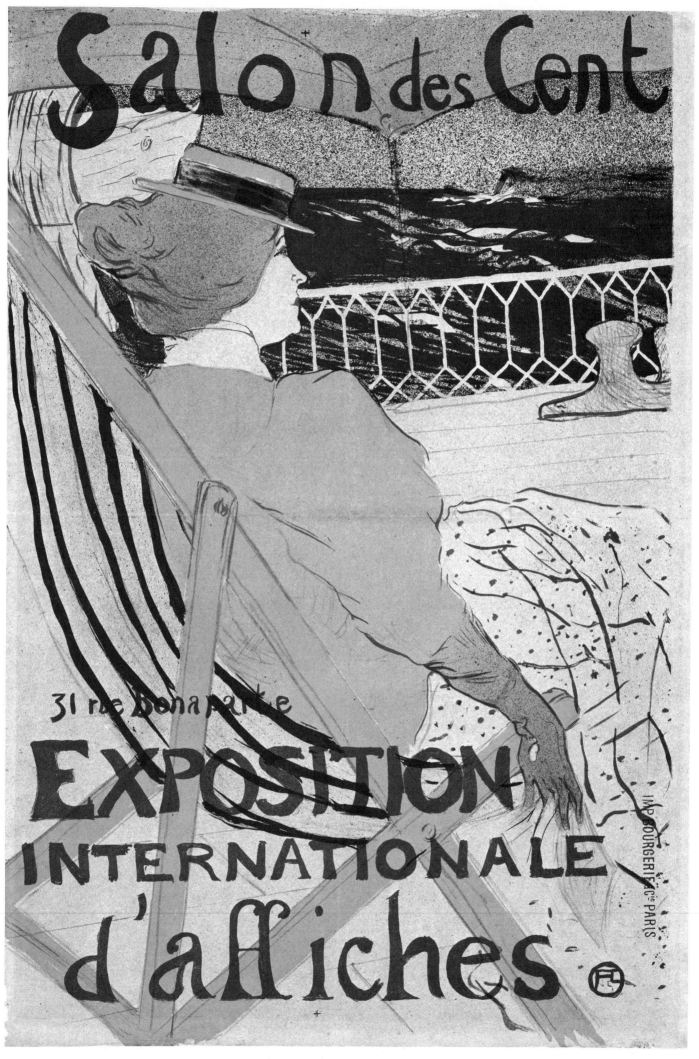

46. The Passenger from Cabin 54 — Promenade on Deck. Poster, 1895.

47. Goodbye. Song-sheet cover, 1895.

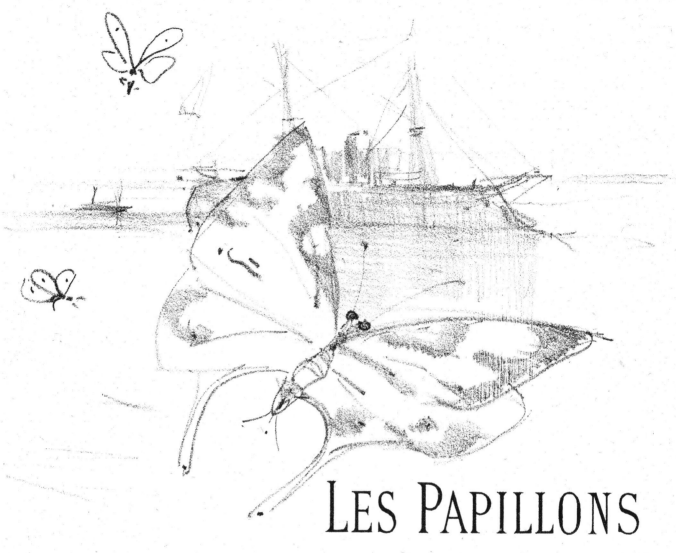

A Mademoiselle Jeanne SELLE.

LES PAPILLONS

Rondo

Poésie de

 Jean RICHEPIN

Musique de

Désiré DIHAU

Piano: 5f
Pt Format: 1f

C. JOUBERT Editeur, 25, Rue d'Hauteville.
Paris

48. The Butterflies. Song-sheet cover, 1895.

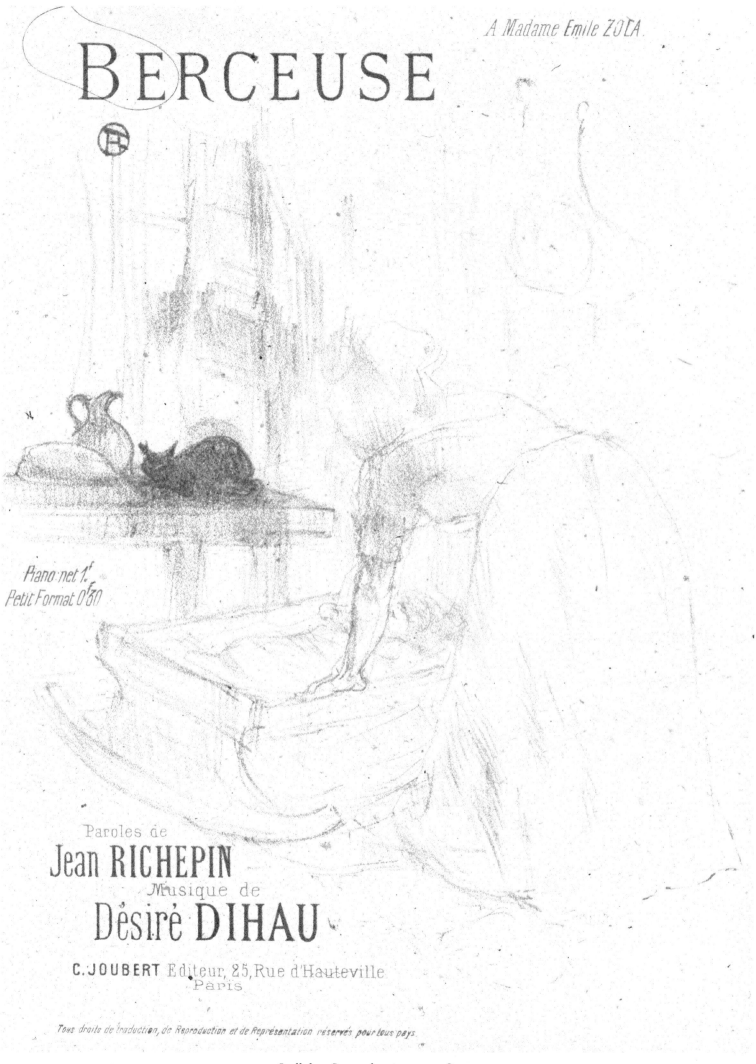

49. Lullaby. Song-sheet cover, 1895.

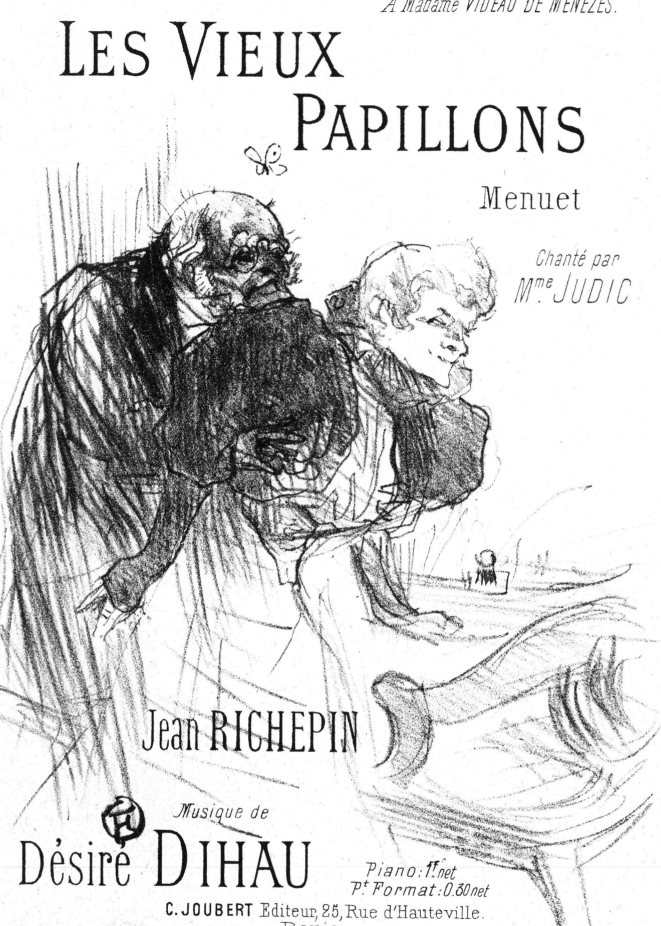

50. The Old Butterflies. Song-sheet cover, 1895.

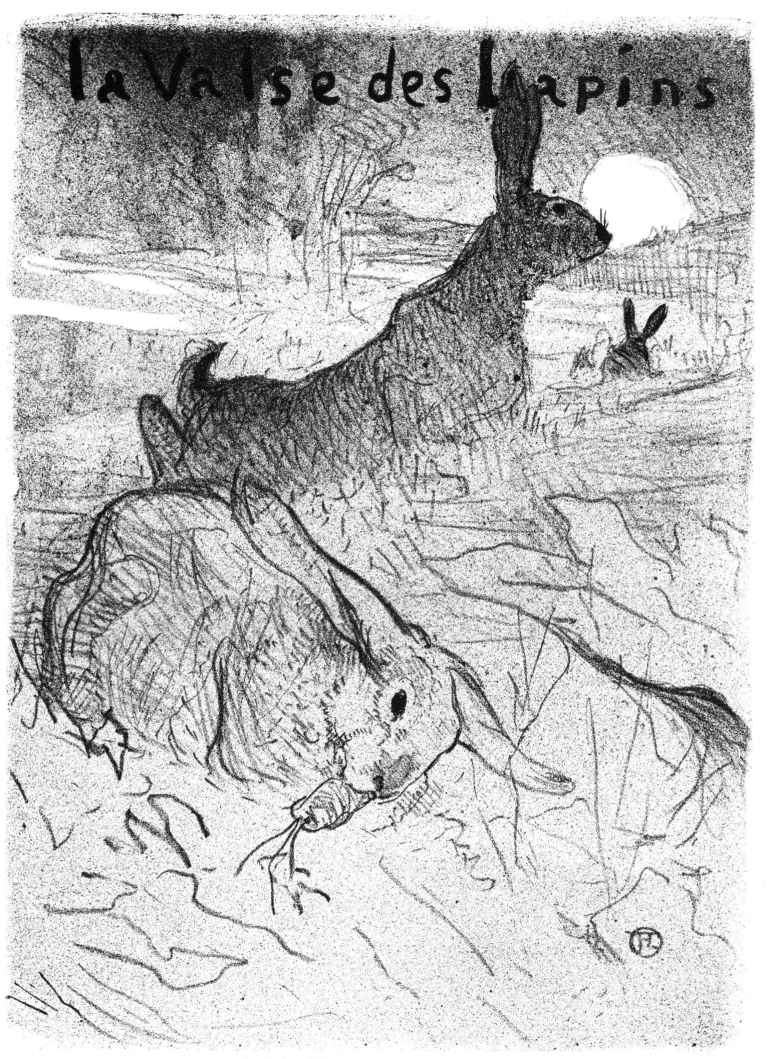

51. The Waltz of the Rabbits. Song-sheet cover, 1895.

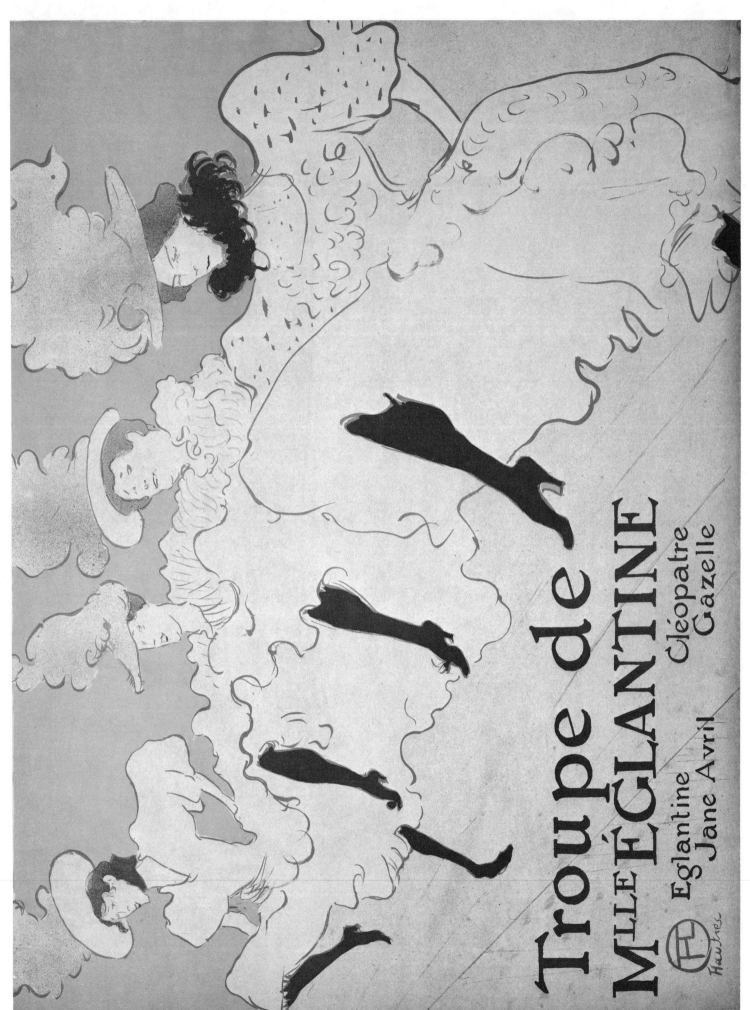

52. Mlle Eglantine's Troupe. Poster, 1896.

53. The Arton Trial — Ribot's Testimony. 1896.

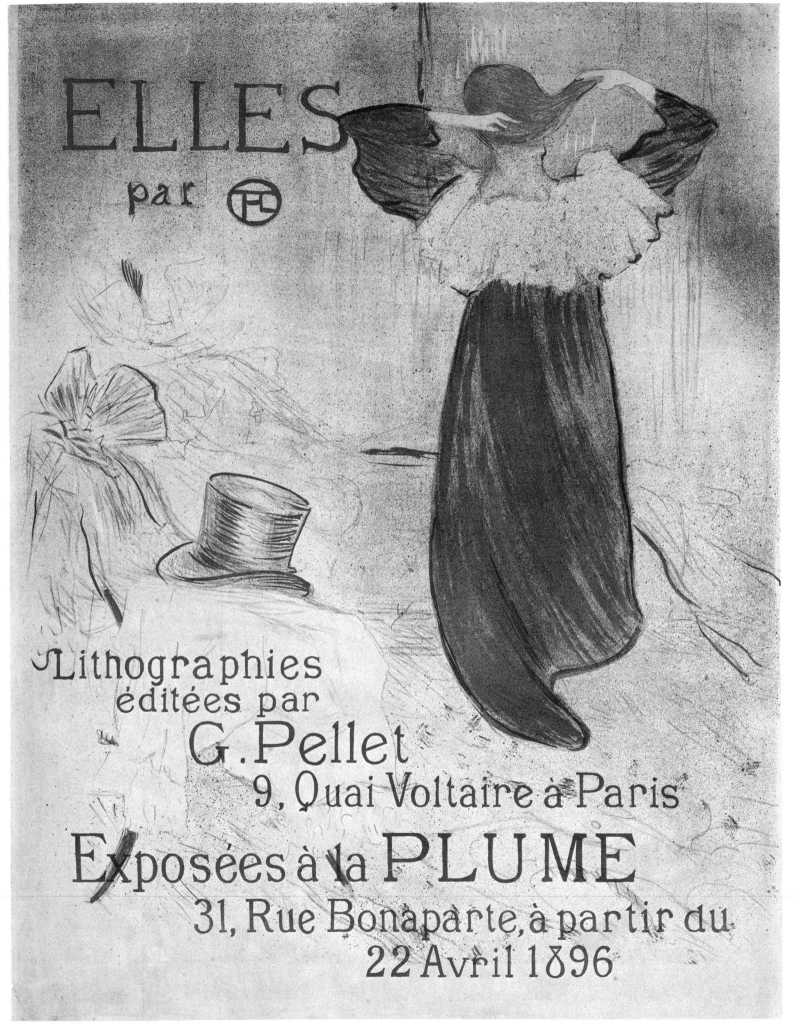

54. *Elles* (Women). Poster, 1896.

55. Woman with Tray — Breakfast — Mme Baron and Mlle Popo. Plate 2 of
Elles, 1896.

56. Woman in Bed — Awakening. Plate 3 of *Elles*, 1896.

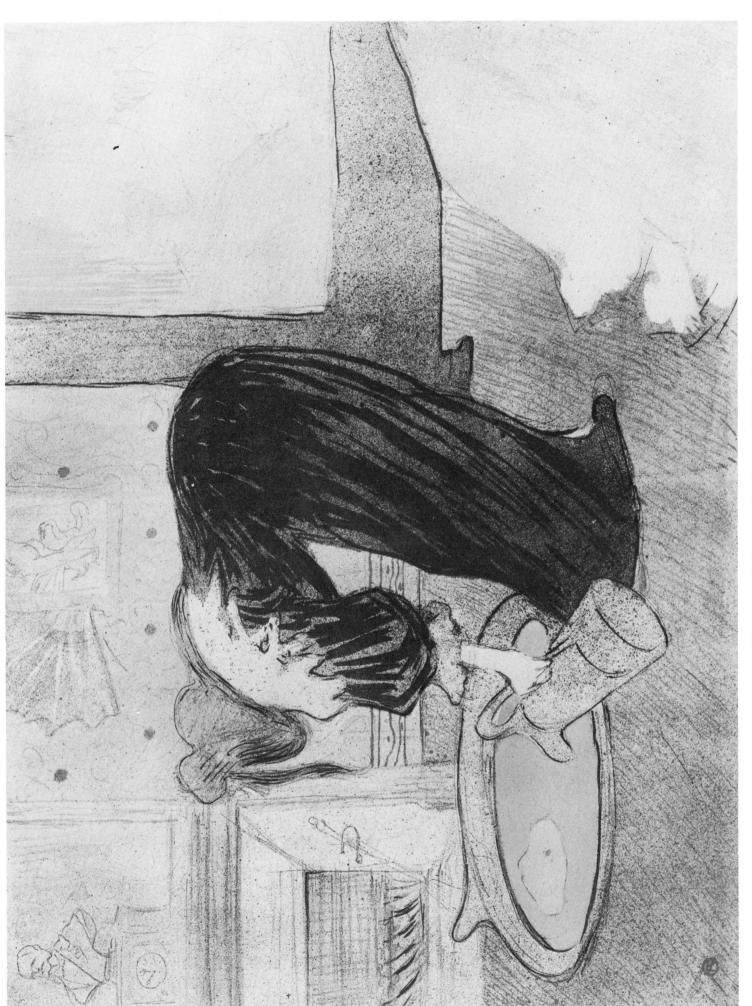

57. Woman with Wash Basin. Plate 4 of *Elles*, 1896.

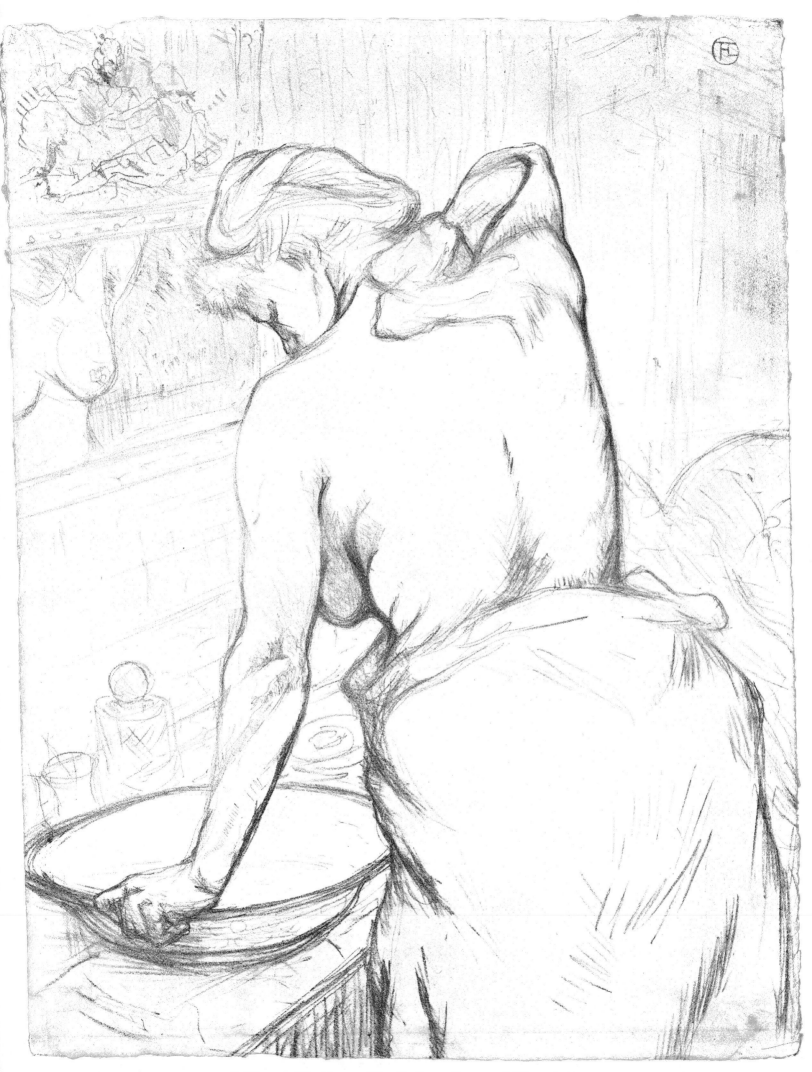

58. Woman Washing — The Toilette. Plate 5 of *Elles*, 1896.

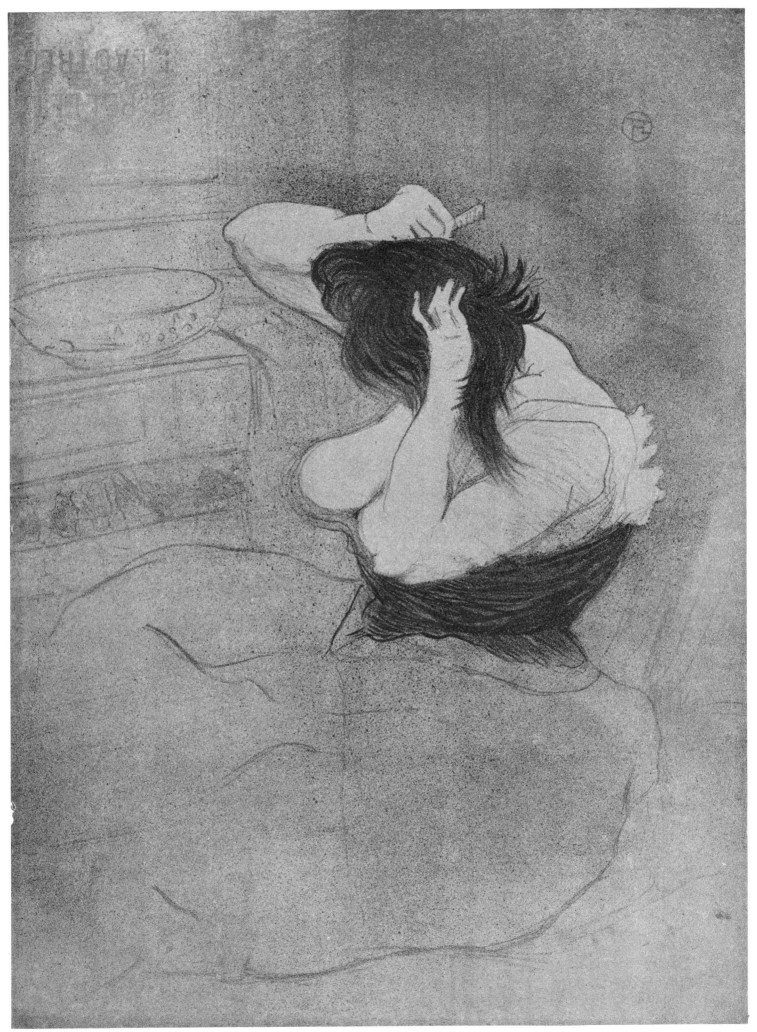

59. Woman Combing — The Hairdo. Plate 7 of *Elles*, 1896.

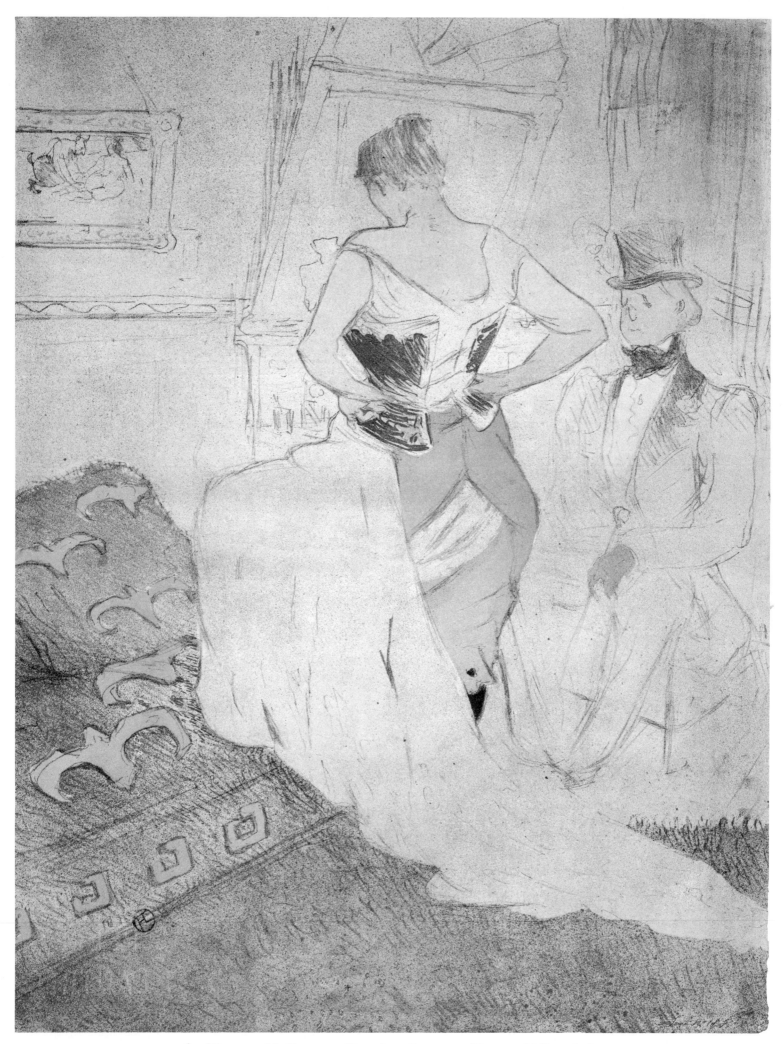

6o. Woman with Corset — Transient Conquest. Plate 9 of *Elles*, 1896.

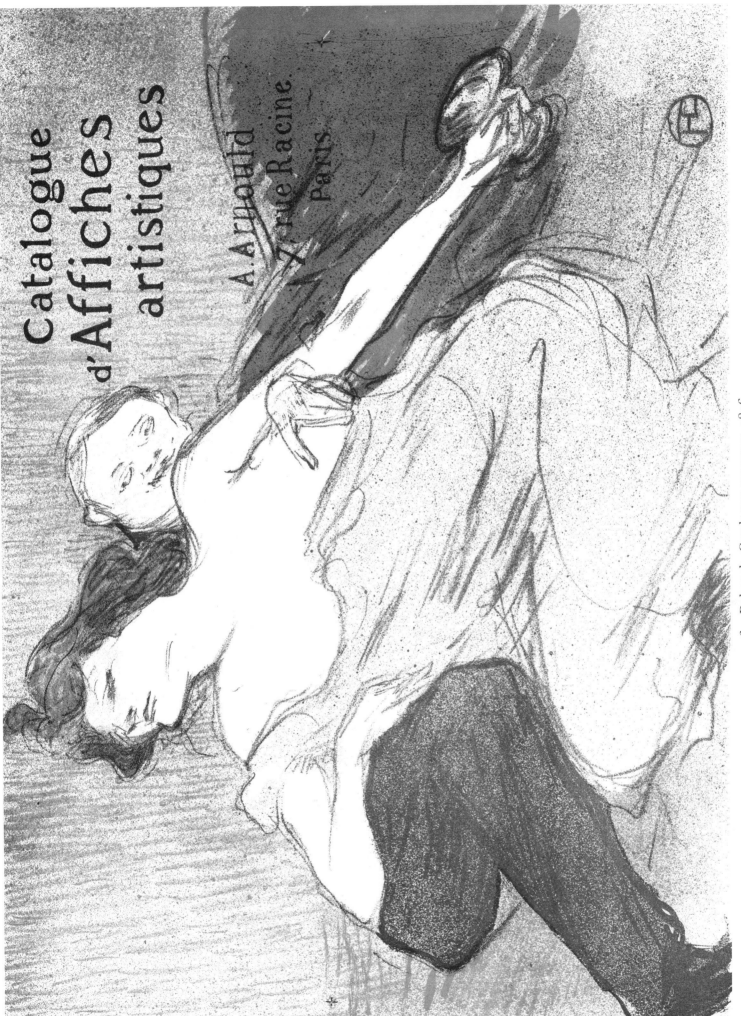

61. Debauch. Catalogue wrapper, 1896.

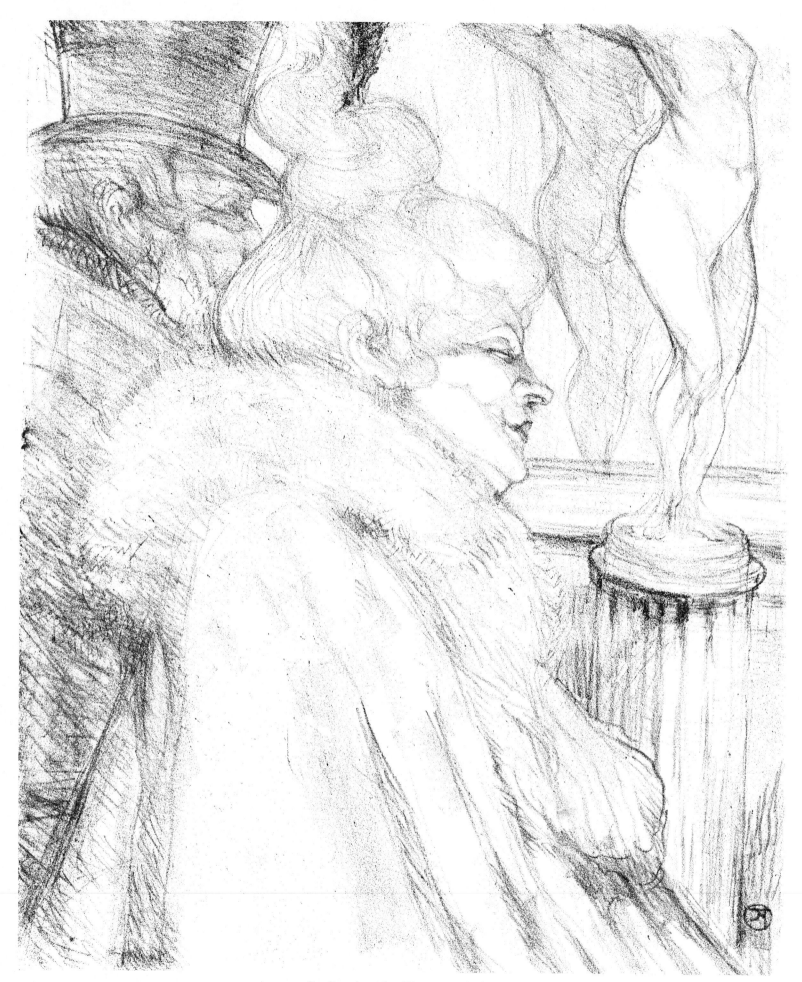

62. Leaving the Theater. 1896.

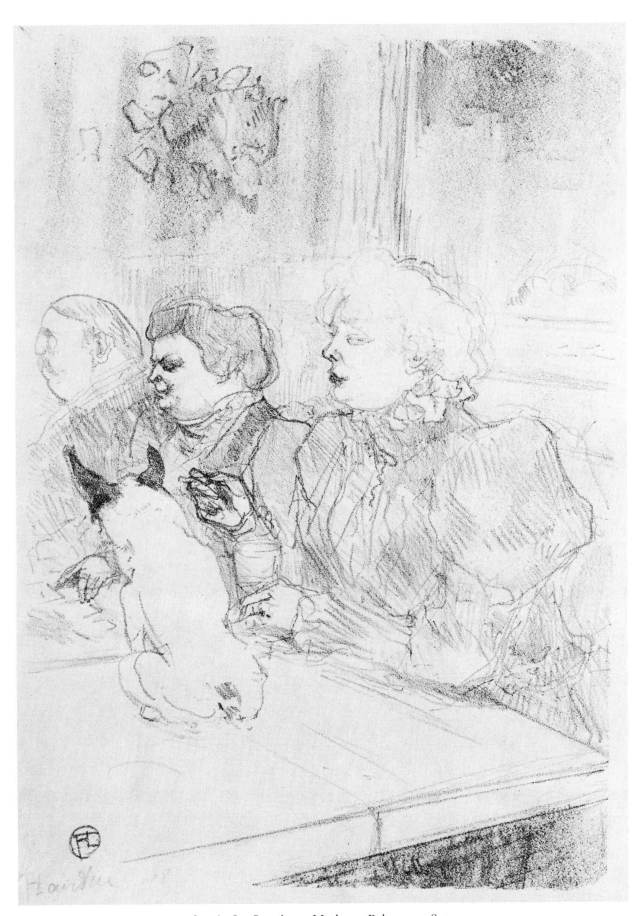

63. At La Souris — Madame Palmyre. 1897.

Flaurec No 2/12

64. The Little Box. 1897.

65. Cover for *The Brief Joys*. 1897.

66. Homage to Molière. Wrapper for *Outside the Law*, 1897.

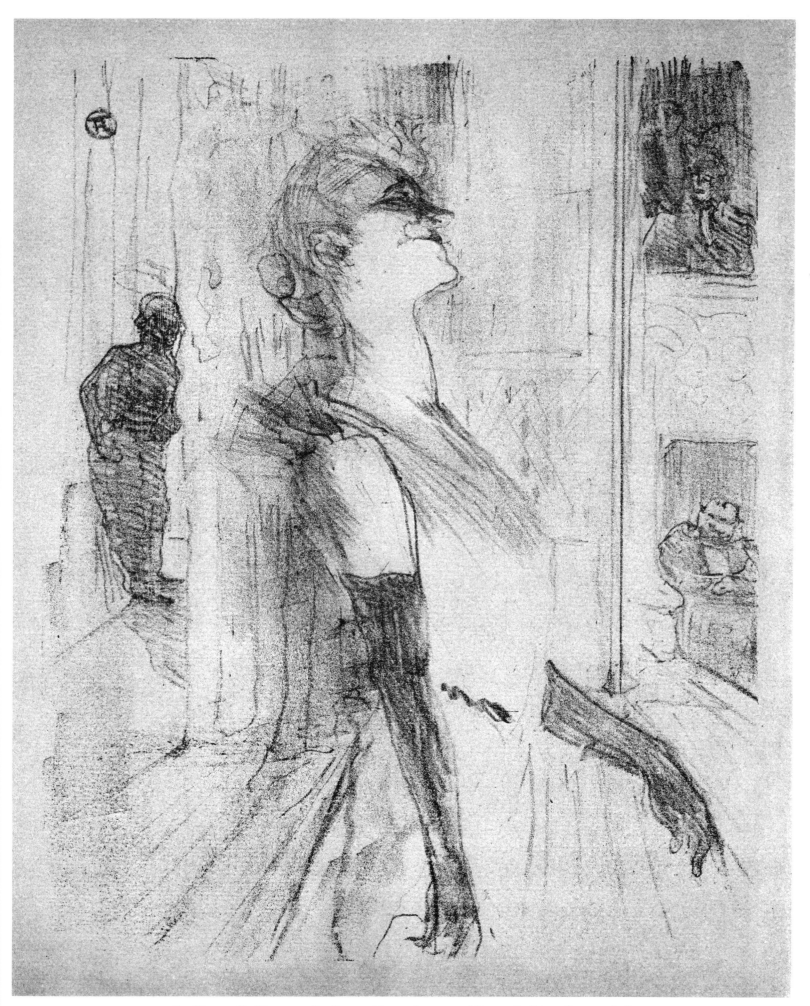

67. Yvette Guilbert — On Stage. From the second *Yvette Guilbert* album, 1898.

68. Yvette Guilbert — Pressima. From the second *Yvette Guilbert* album, 1898.

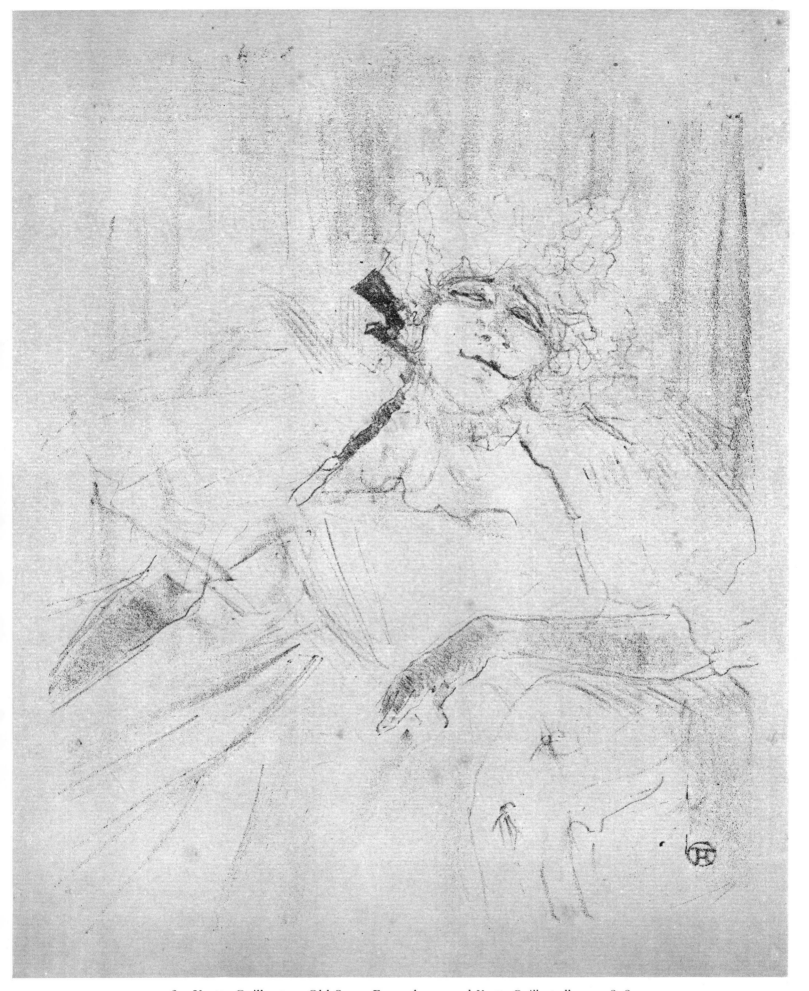

69. Yvette Guilbert — Old Song. From the second *Yvette Guilbert* album, 1898.

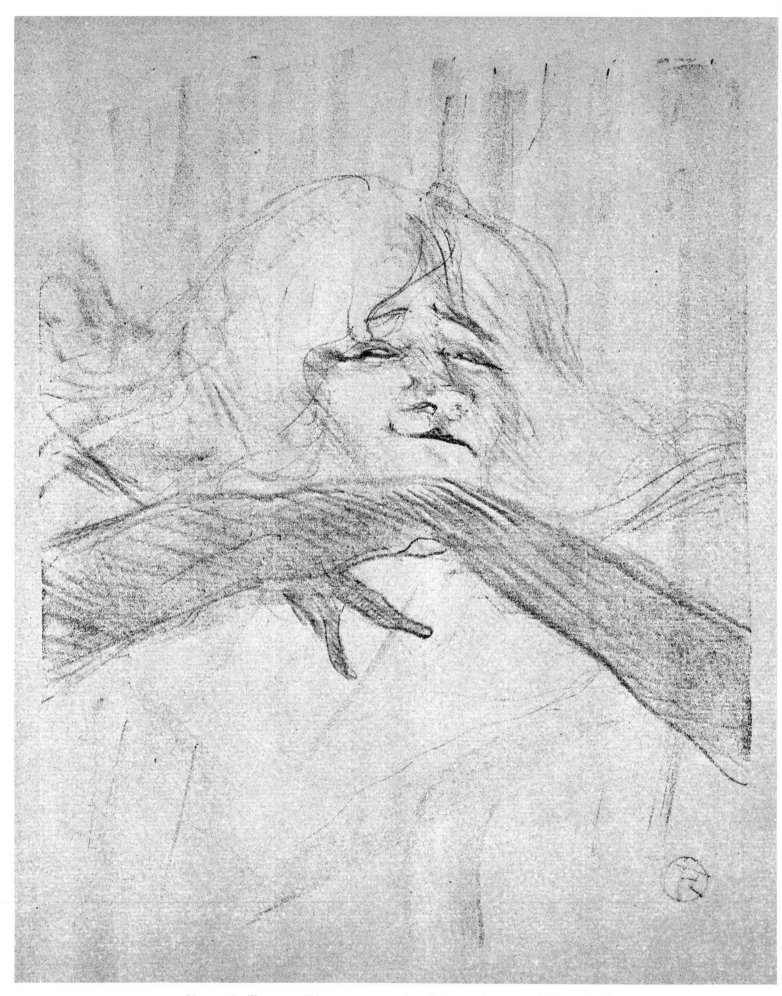

70. Yvette Guilbert — "Linger Longer, Loo." From the second *Yvette Guilbert* album, 1898.

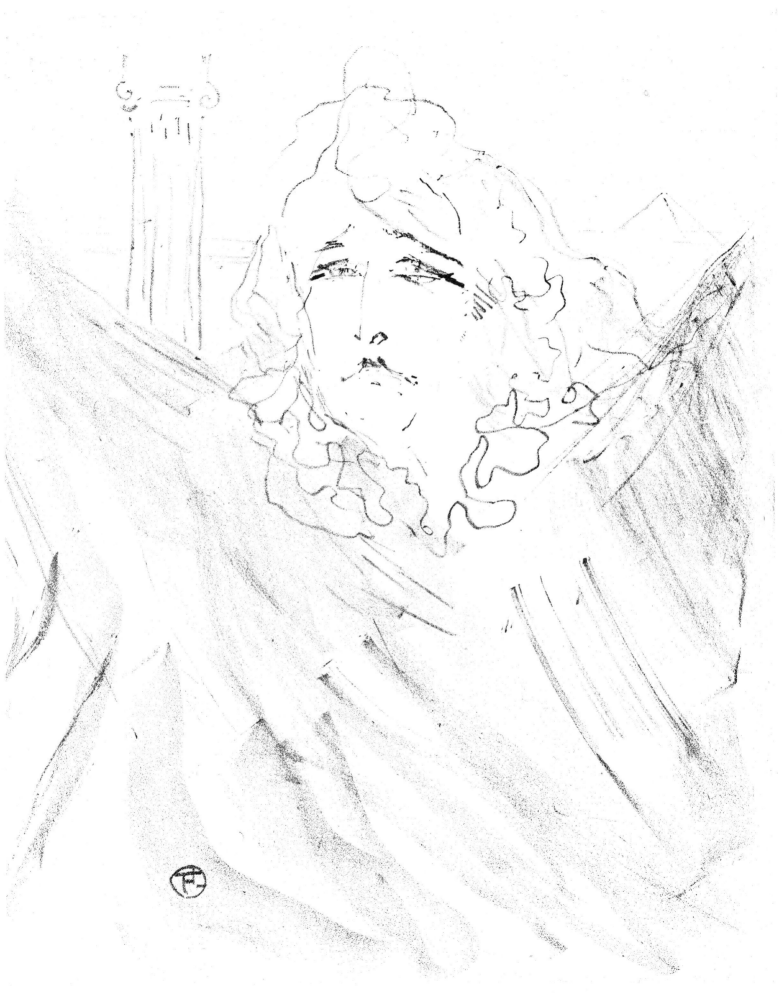

71. Sarah Bernhardt in *Cleopatra* (?). From *Portraits of Actors and Actresses —
Thirteen Lithographs*, 1898.

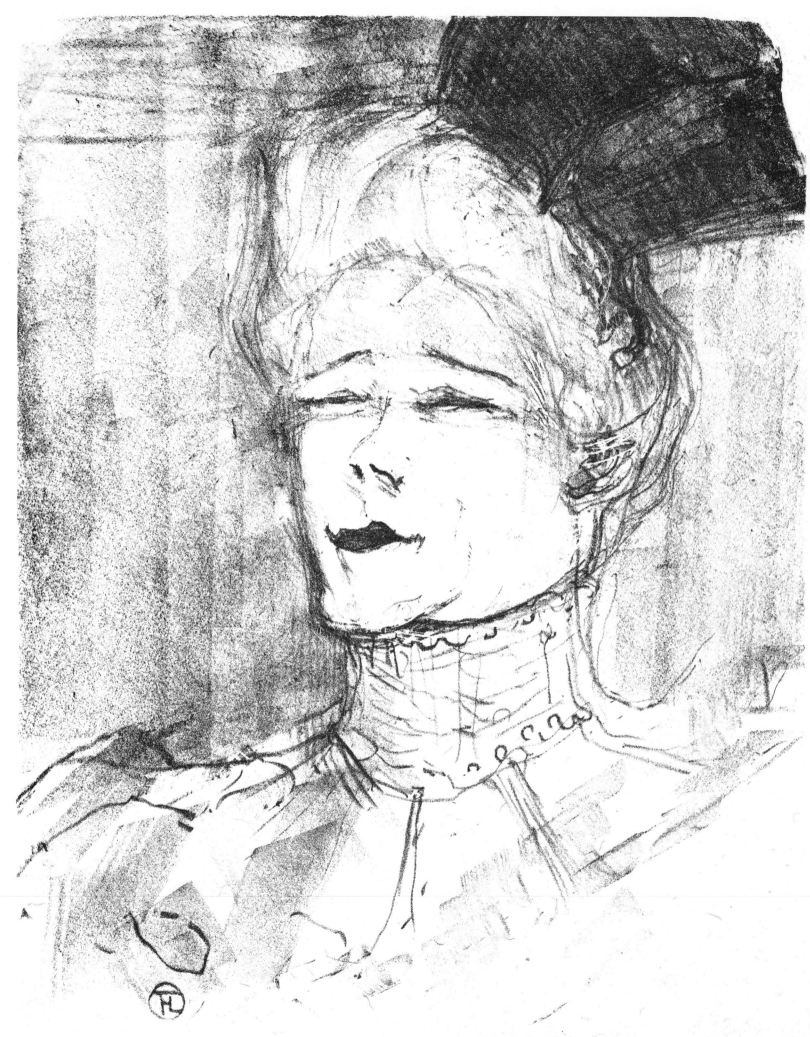

72. Jeanne Granier. From the *Thirteen Lithographs*, 1898.

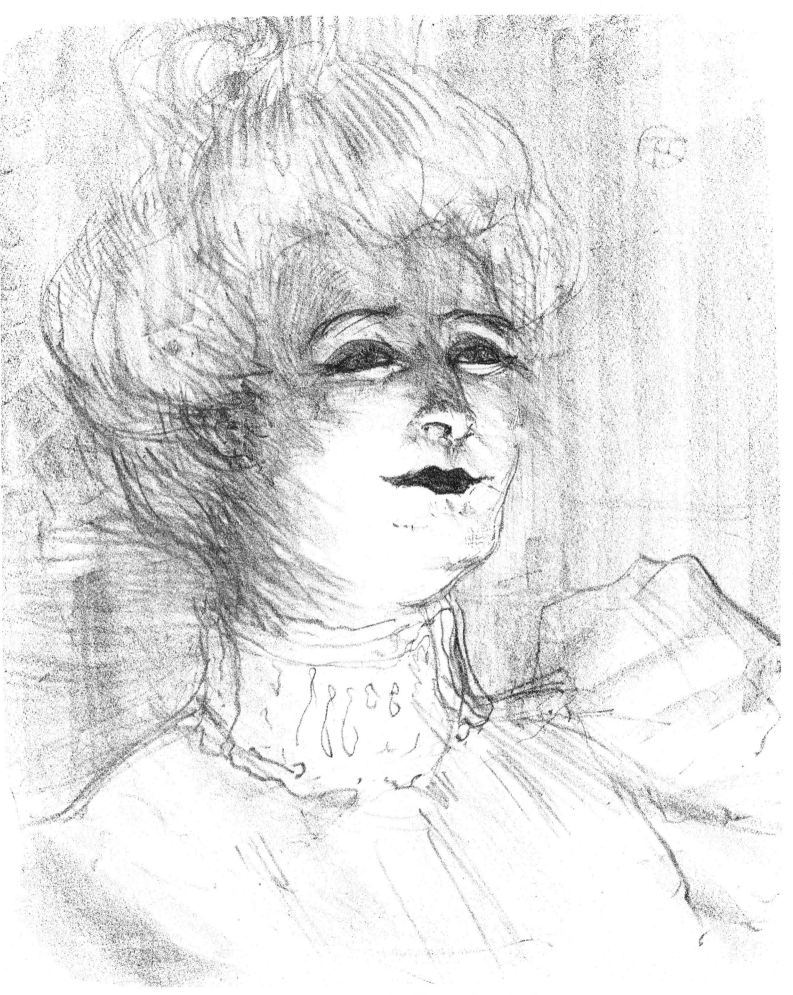

73. Jeanne Hading. From the *Thirteen Lithographs*, 1898.

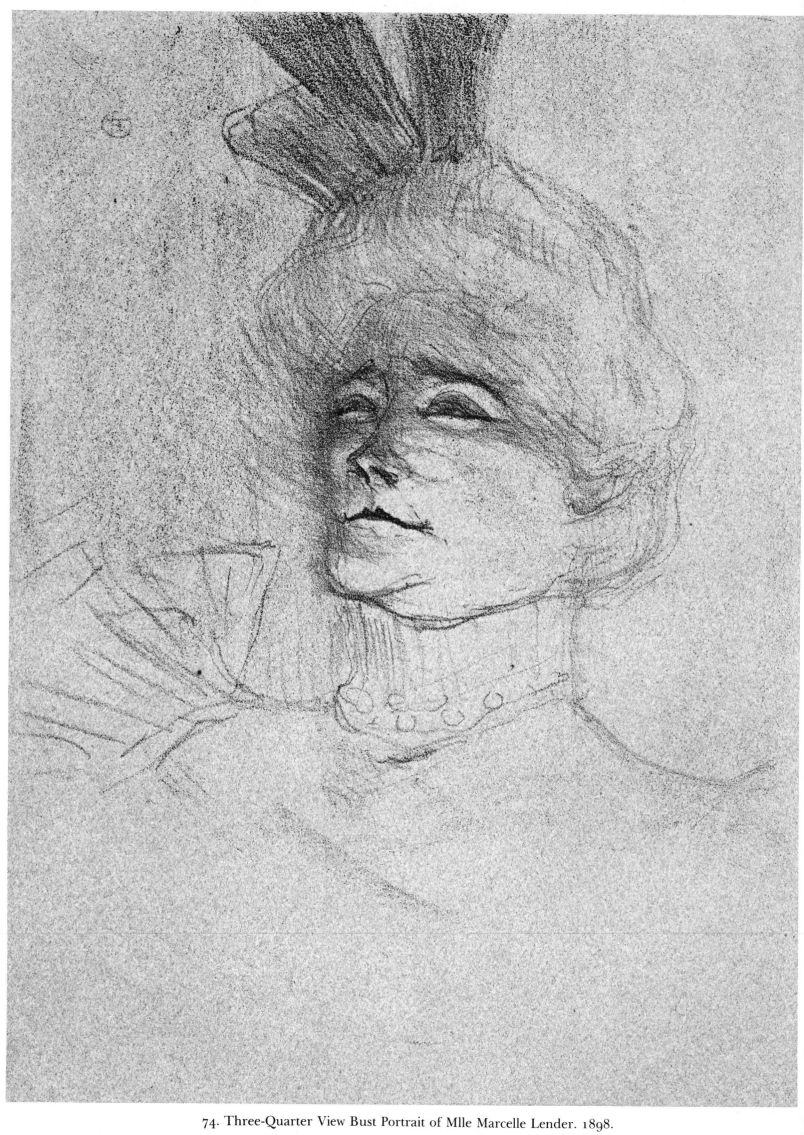

74. Three-Quarter View Bust Portrait of Mlle Marcelle Lender. 1898.

75. Cover for *The Example of Ninon de Lenclos in Love*. 1897.

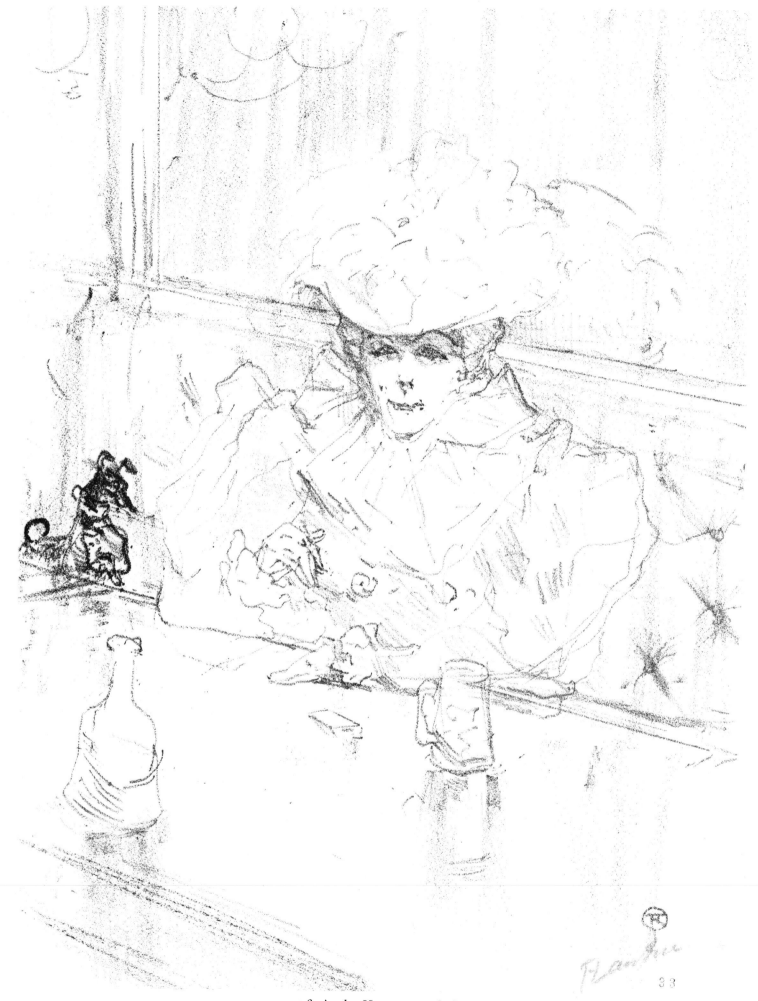

76. At the Hanneton. 1898.

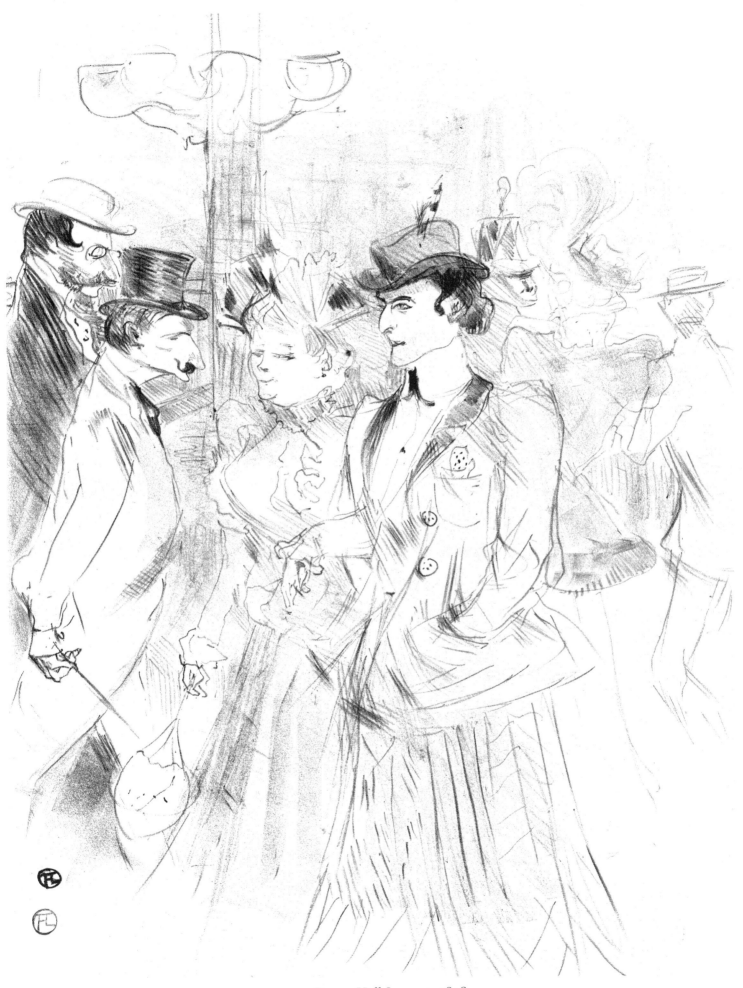

77. Dance-Hall Lounge. 1898.

L'Epervier

78. The Sparrow Hawk. From *Natural Histories*, 1899.

L'Araignée

79. The Spider. From *Natural Histories,* 1899.